A Hard-Water World

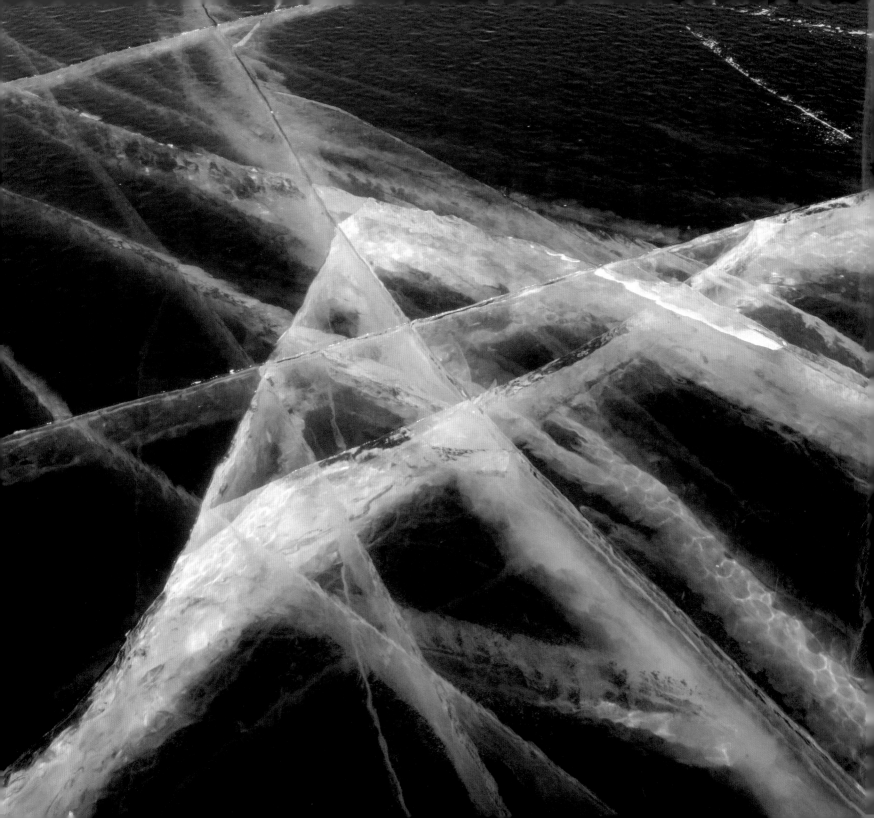

A Hard-Water World

Ice Fishing and Why We Do It

PHOTOGRAPHS BY Layne Kennedy
ESSAYS BY Greg Breining

MINNESOTA HISTORICAL SOCIETY PRESS

www.mhspress.org

The Minnesota Historical Society Press is a member of the Association of American University Presses.

Book and jacket design: Brian Donahue/bedesign, inc.

Manufactured in China

10 9 8 7 6 5 4 3 2 1

∞ The paper used in this publication meets the minimum requirements of the American National Standard for Information Sciences—Permanence for Printed Library Materials, ANSI Z39.48-1984.

Page 3: Richard Guindon, copyright 1980 Minneapolis Tribune; originally published Dec. 14, 1980. Republished with permission.

International Standard Book Number
ISBN 13: 978-0-87351-624-2 (cloth)
ISBN 10: 0-87351-624-9 (cloth)

Library of Congress Cataloging-in-Publication Data
Kennedy, Layne, 1957-
A hard-water world : ice fishing and why we do it / photos by Layne Kennedy; essay by Greg Breining.
p. cm.
ISBN-13: 978-0-87351-624-2 (cloth : alk. paper)
ISBN-10: 0-87351-624-9 (cloth : alk. paper)
1. Ice fishing. 2. Ice fishing—Pictorial works. I. Breining, Greg. II. Title.
SH455.45.K46 2008
799.12'2—dc22
2008000829

Acknowledgments

Producing a creative book requires considerable help from people whose names do not appear on the cover. Special thanks to the Minnesota Historical Society Press's Editor in Chief Ann Regan, who caught wind of this effort and reeled it in, and to ace editor Marilyn Ziebarth and production manager Will Powers at the press, who guided this book safely across the ice. Thanks also to Greg Britton, former publisher, for his willingness and enthusiasm to take on this fabulous sidebar story to winter, and to designer Brian Donahue, for his great intuition and skilled design sense.

Additional thanks go to Mike and Sue Prom of Voyageur Canoe Outfitters on Minnesota's Gunflint Trail, who graciously offered their services for a jaunt into the wilderness; to Albert Lane and his wife Jennifer (Dusty) of Androscoggin Guide Service in Maine, who fed me and took me by dog team to an exciting fishing location in the Bigelow Range; to Bill Brent in Portland, Oregon, who generously offered special photographic equipment even when he knew his gear was at risk; to Glenn Monahan, who allowed me to strap special lenses on his ice boat in Montana for a shot I had only dreamed was possible; to Diane Meyer of the Oshkosh Convention & Visitors Bureau, who spent two days crisscrossing Lake Winnebago looking for fishing hot spots; and to Wayne Kryduba for all his advance work. A special thank you to Greg Breining, with whom I have happily traveled this amazing planet. And, finally, to my wife Martha and our children, Croix, Brooks, and Austin, for listening to my stories and sharing many of the experiences. Those are the days I cherish most.

// LAYNE KENNEDY

Thank you to Dick Sternberg and Mike Hehner, who taught me a lot about ice fishing when I worked with them on a series of angling books many years ago. I'm also indebted to my friends Jim and Tracy Weseloh, who took me fishing on several lakes in northeastern Minnesota. My friend Oleg Voskresensky proved incredibly determined and skillful as an interpreter and "arranger" for our expedition on Russia's Volga River. Finally, I'd like to thank the staff of the Minnesota Historical Society Press, who recognized the potential of a book on this quirky sport of the North.

// GREG BREINING

Contents

Celebration of the North

Celebration of the North

If you didn't grow up in northern climes, ice fishing may seem improbable, wacky, and perhaps a bit dangerous. The very words, "ice fishing," suggest the bleakest aspects of northern winters and stoic people—and even a parody of life in the rural North.

Perseverance bordering on complete inertia. A dull sport for a dull people. After all, how much skill can it take to sit on a bucket, hold a jigging rod, and stare into a hole?

Being a good-humored bunch, we accept and revel in the stereotype, even though we know that ice fishing actually takes quite a bit of skill. (You who haven't fished through the ice, try not to laugh.) Those of us whose blood ran cold at birth or who at least have lived a few years in this country of bitter winters, deep snow, and howling winds know that fishing on the ice—and driving on the ice—and even dragging houses onto the ice—*does* in fact seem wacky. And so we can find humor in a cartoon that depicts ice fishing "practice" as sitting in an empty gym on folding stools.

Many of us who live where lakes turn hard several months of the year are anglers, after all. We refuse to accept that our beloved sport has come to an end. So we chop a hole. One could say that we are metaphorically destroying the barrier that comes between us and our fishing.

For others, ice fishing is simple escape: it is all about the outdoors, the solitude, the beer, and the tinny sound of the Sunday football games on the 1960s transistor radio on the two-by-four in an ice shack—a simple antidote to cabin fever. Ice fishing is something to do that seems, on occasion, focused, and, sometimes, even productive.

For a few, ice fishing is not an alternative, not second best at all. It is the best kind of fishing. These people like the cold, the ice, the roar of the auger, the speed of the snowmobile, the thrill of driving on ice, and the delicious taste of fish from clean, cold water.

Harold F. Blaisdell, in the ice fishing entry to the 1980 edition of *McLain's Fishing Encyclopedia*, makes a valiant stab at the appeal of ice fishing. "Perhaps the greatest single source of fascination is the drastic change in the relationship between man and water brought about by the dramatic appearance of the ice itself," Mr. Blaisdell writes. "The waters which now lie hidden beneath the frozen surface immediately become a dark, sealed-off mystery and thus pose a tantalizing and compelling challenge to the fisherman."

I'm not sure if Mr. Blaisdell has stared into his ice hole for too many long hours or if he simply has been more imaginative than the rest of us.

WE ICE FISHERMEN, being not only good-humored but endowed with a sense of irony, proudly accept ice fishing as an emblem of our life in the frozen boonies. We sign our e-mail "I Love Crappie Days" or, my favorite, "I will be on the couch watching cartoons in my underwear until it gets cold!" Our embrace of something so odd as ice fishing is an expression of mild-mannered populism. As Garrison Keillor has said, "We come from people who brought us up to believe that life is a struggle." Ice fishing is our cultural connection with the Wobegon Nation.

Certain elements stand out in the mythology of ice fishing. Like beer, or escape from the spouse. The mythology is actually rather thin, which may explain why so little has been written about ice fishing—other than how to drill holes faster, how to use fish finders through the ice, and how to keep your minnow lively.

Writer D. J. Tice, a friend of mine, has contributed to the literature of ice fishing, which is to say he wrote about ice fishing once. Doug has the advantage of a fresh perspective unencumbered by a lot of actual experience. He writes, "After learning that the principle action in ice fishing is checking one's minnow, after beginning to worry that my bait was holding up better than I was—after all this the truth was suddenly revealed unto me. What's the fun in ice fishing? One might as well ask what fun medieval pilgrims found in trudging barefoot to Jerusalem or what kick Eastern mystics derive from hair shirts and self-flagellation.

"The secret that tens of thousands of Minnesota ice anglers share is this: Ice fishing has nothing whatever to do with 'sport' or 'fun.' It is an exotic

Minnesota rite of mortification, preparing the ice fisher for life's pangs, disappointments and tedium—it's especially good for tedium."

WHETHER OR NOT ICE FISHING really prepares us for life's trials is debatable. It is more important to realize that ice fishing is our cultural marker.

When it comes to fishing, I have always been drawn to running water, the visibility of the depths, the athleticism of casting, and the fight of the fish as it cavorts on the surface and whipsaws the line in mighty runs. So compared with open-water fishing, "hard-water" angling has always run a poor second. But I began to see ice fishing in a different light one winter day as I traveled through Moscow and saw men sitting on a frozen river, staring down at the ice. I knew immediately what they were up to. My innate knowledge of ice fishing, absorbed during a lifetime of living in Minnesota, marked me as a northerner, a member of a circumpolar clan, a secret society of winter sportsmen. Despite the strangeness of their culture and their horrible political and economic system (communist at the time), aspects of their traditional customs I fully understood.

Ice fishing is to northerners what elaborate tattoos might be to South Sea Islanders. Ice fishing is the identity we carry with us (figuratively speaking) in the sled with the five-gallon buckets filled with jigging rods, the ice scooper and the power auger, the portable ice shelter and the propane heater. As we trudge across the first ice of the season, it is what we cling to more than a life vest: it is our cultural-tribal link. *You may think we're nuts, but this is who we are!*

That's our story and we're sticking to it.

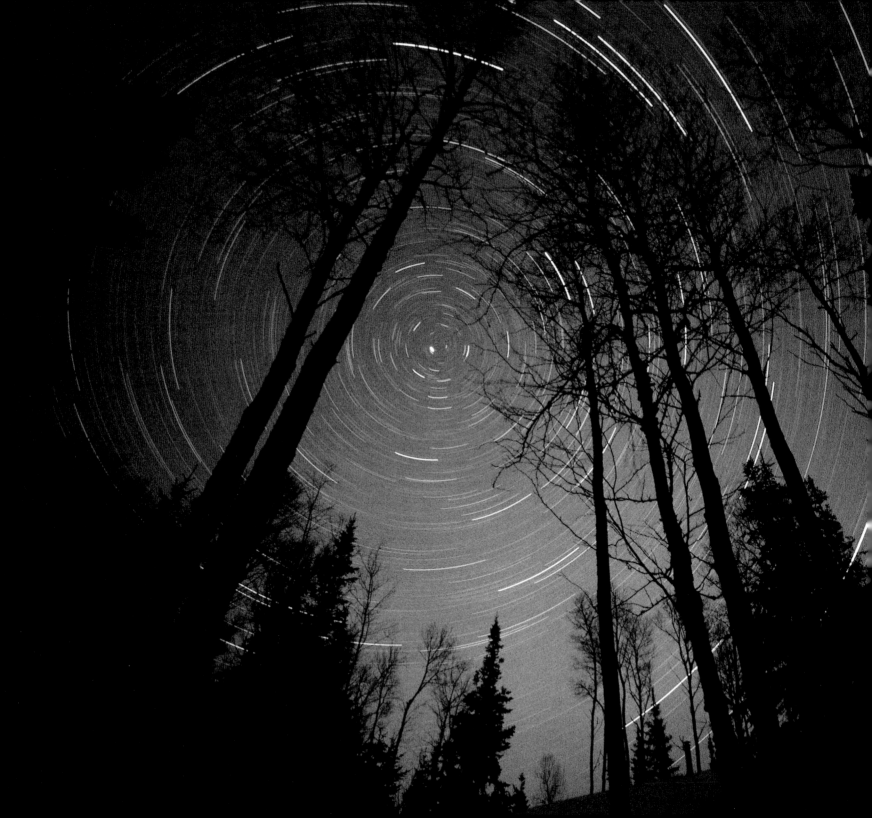

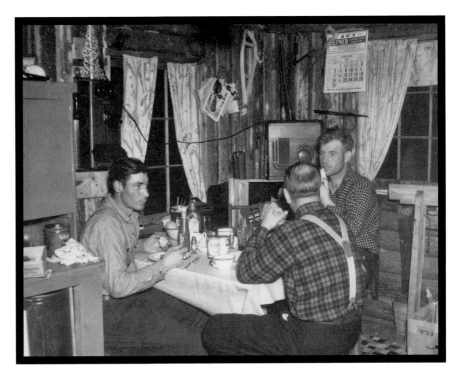

⬆ Fishing trip, Lake Saganaga, Minnesota, 1938.
(MINNESOTA HISTORICAL SOCIETY)

⬅ Winter stars, time exposure, Superior National Forest in northern Minnesota.

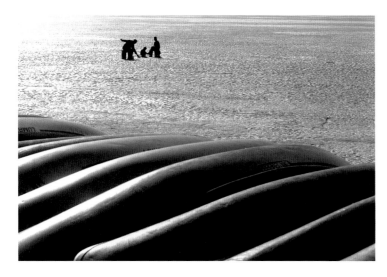

⇐ Ice anglers and rental canoes stored on the shore of Lake Calhoun in Minneapolis.

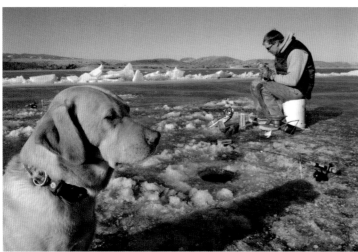

⬆ Bill Martian and Bosco near a pressure ridge, Canyon Ferry Reservoir, Montana.

⬈ Catching a fish on the Missouri River near Williston, North Dakota.

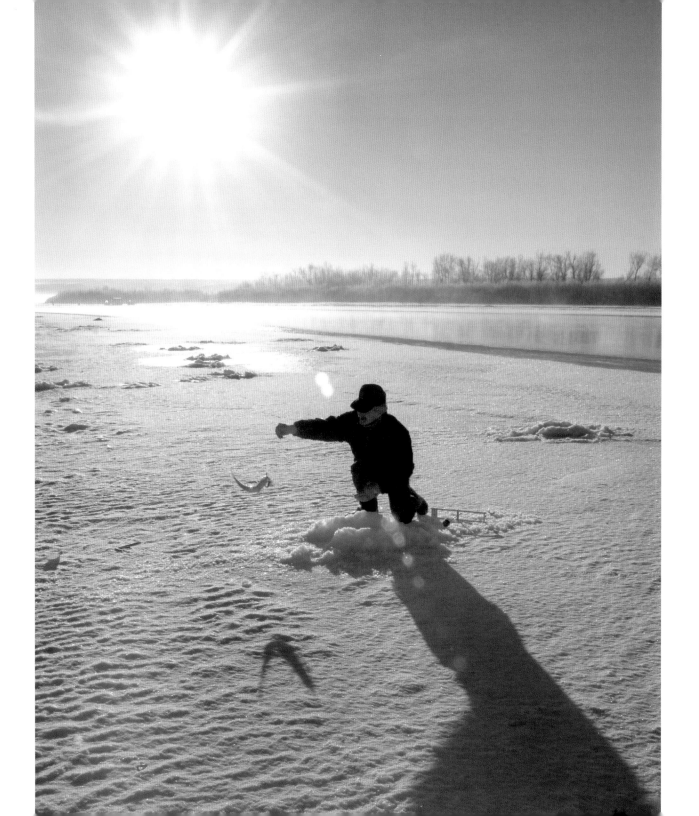

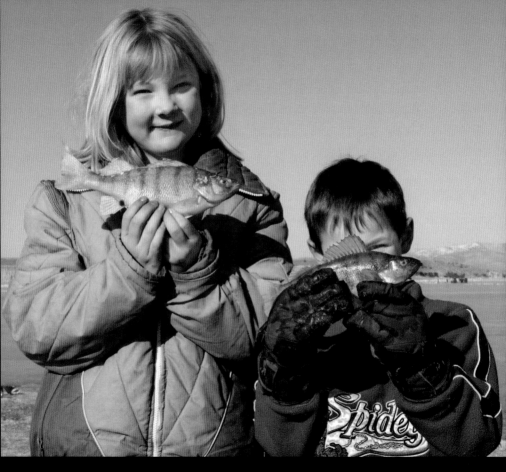

Kindra Dunlap, age 7, and brother Justis, age 6, with yellow perch.

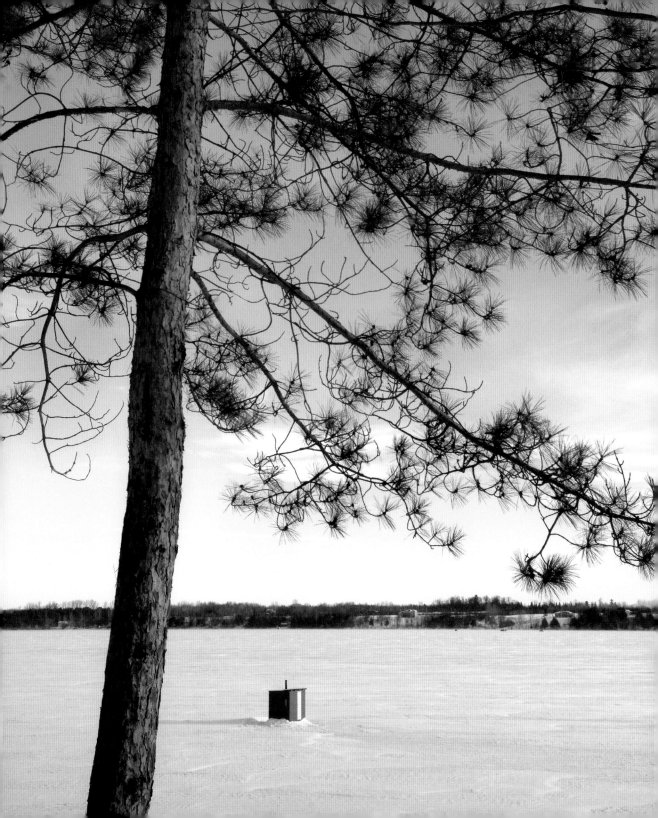

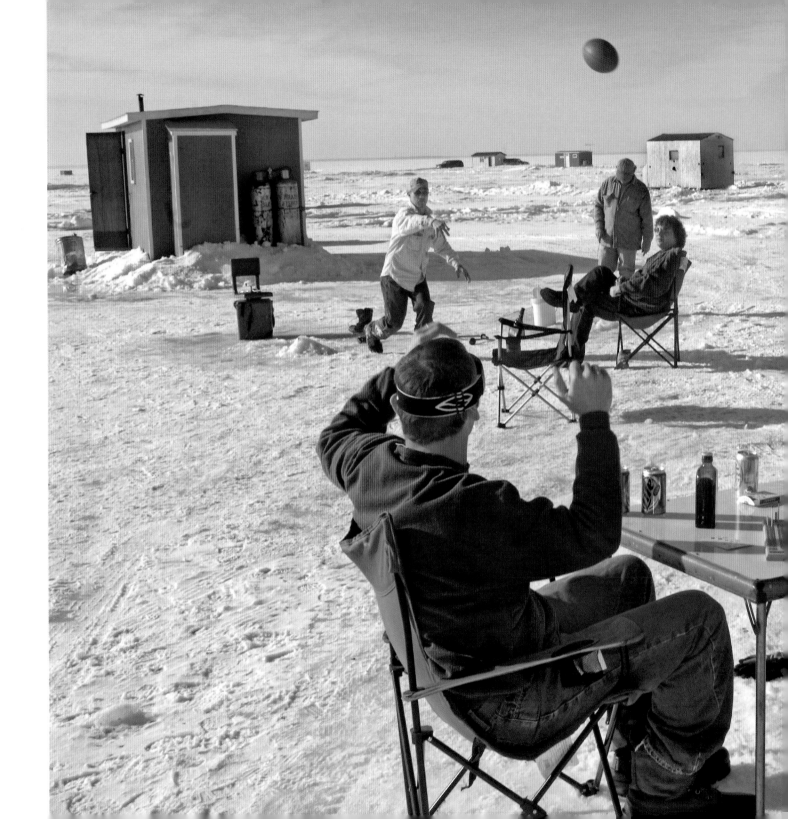

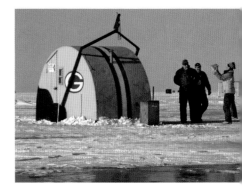

⬆ Green Bay Packer fans,
Lake Winnebago,
Wisconsin.

⬅ Multitasking, Mille Lacs Lake, Minnesota.

11

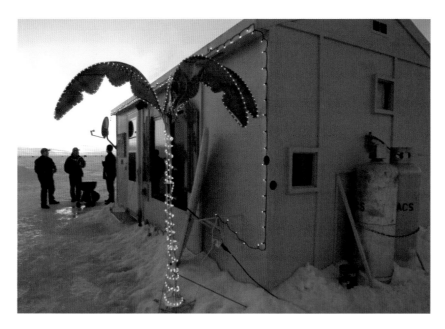

⬆ Wishful thinking, Mille Lacs Lake.

➡ Ice sailing, Canyon Ferry Reservoir.

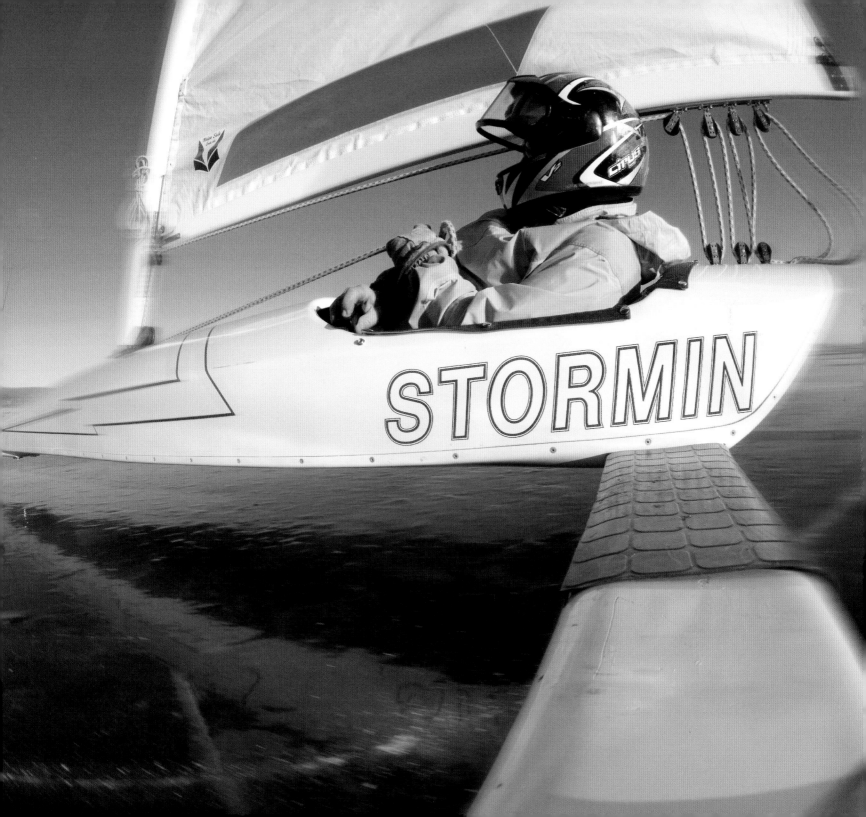

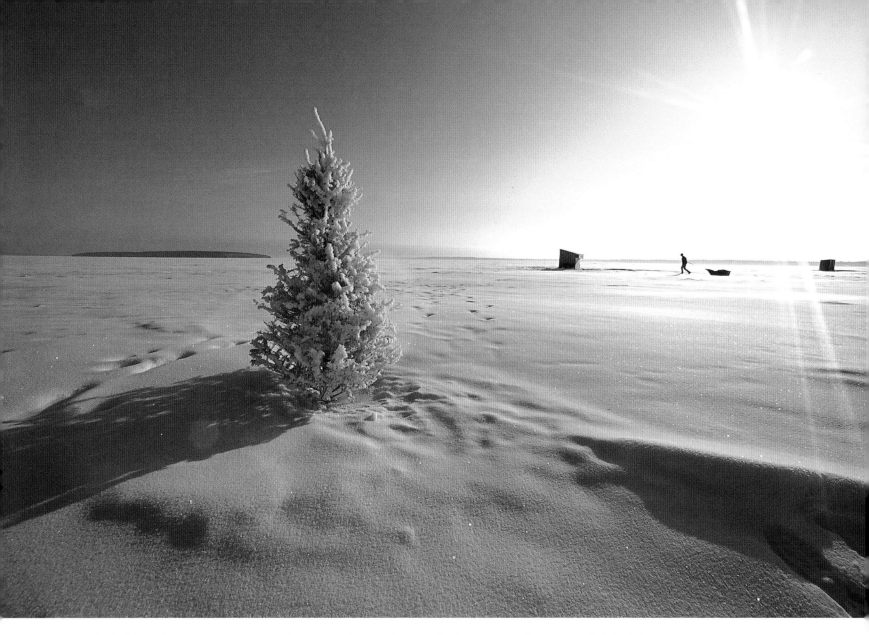
⬆ Christmas tree marking the edge of an ice road over Lake Superior between Bayfield and La Pointe, Wisconsin.

Lake trout, through the plastic of a makeshift shelter, Sebago Lake, Maine.

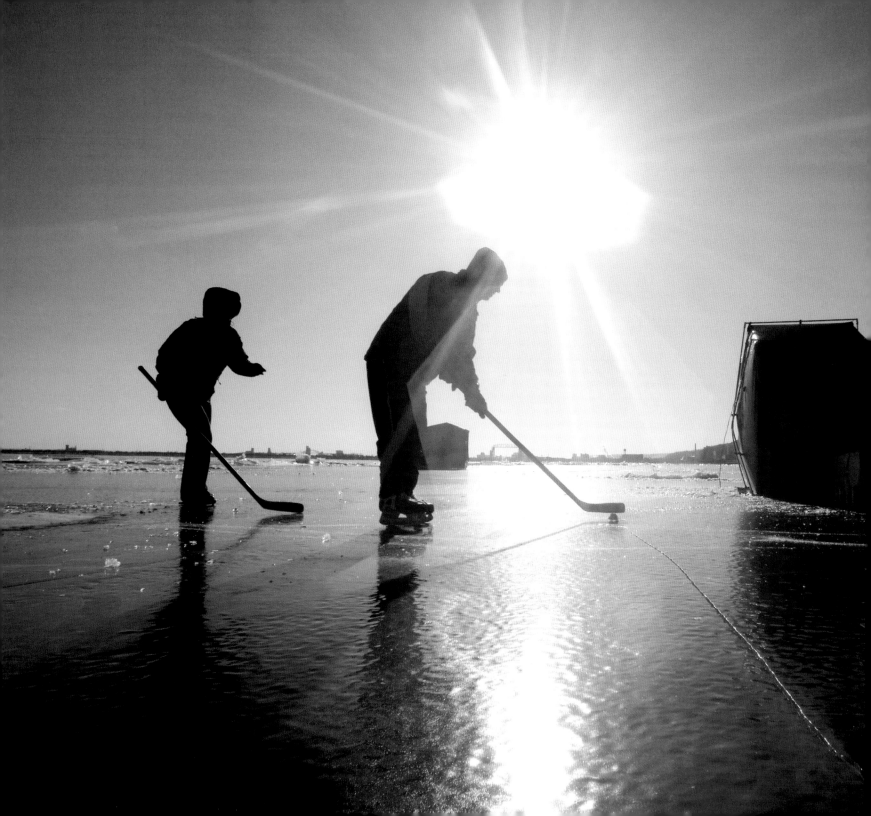

← Hockey on Lake Superior, Duluth, Minnesota.

First Ice

First Ice

For days the frigid wind howled from the north. The temperature of the water had dropped below freezing, but the waves held the ice at bay. Slush piled up along the shore. The wind blew into the bitter night.

In the morning, I woke to silence and looked out the window: a fresh sheet of ice stretched shore to shore, a glistening mirror that reflected sun and clouds. A new beginning, a new world.

During the following days the lake groaned, cracked, boomed, and warbled like a saw. The ethereal whine ricocheted around the perimeter of the lake, a clarion call of the cosmos. The sounds, I read, are caused by the movement and compression of the ice under pressure. Many forces are at work on the ice sheet—expansion from the act of freezing, stretching and contraction due to changes in temperature from sunlit days to frigid nights, and the pressure of the wind as it drives one sheet of ice into another. The pressure building in the lake ice is analogous to the force along the fault lines in the Earth's crust: in the ground, the

tension dissipates with the violence of an earthquake; in the ice, it manifests as a jagged crack racing through the newly formed sheet for hundreds of yards.

In the dense, pure medium of new ice, the sounds of these stresses ring like music. To Henry David Thoreau, encamped in rural Massachusetts, the singing and booming were known as the "thundering of the pond":

"One pleasant morning after a cold night, February 24th, 1850, having gone to Flint's Pond to spend the day, I noticed with surprise, that when I struck the ice with the head of my axe, it resounded like a gong for many rods around, or as if I had struck on a tight drum-head. The pond began to boom about an hour after sunrise, when it felt the influence of the sun's rays slanted upon it from over the hills; it stretched itself and yawned like a waking man with a gradually increasing

tumult, which was kept up three or four hours. It took a short siesta at noon, and boomed once more toward night, as the sun was withdrawing his influence."

SOMETIME LATER, we dared explore the new ice, walking out from shore in front of the cabin. We shuffled along the surface, as clear as window glass. Our boots passed over sand and snails and the remnants of waterweeds as though the ice didn't exist and we walked on water. As we ventured out farther, we could no longer see the bottom. The ice was clear, with hardly a bubble or anything else to betray its existence. We stood on nothing, just the black void of space. I was hit by vertigo and doubt—my faith was wanting, like that of Peter as he walked on water and began to sink and implored Jesus to save him.

It was only when we came to a crack that we could put our noses down, examining the flaw first from this angle and then the other, and reassure ourselves we stood on at least four inches of ice, a safe minimum for walking. Even that was hardly comforting, for the fissure seemed to penetrate the entire thickness of the sheet for many yards in each direction.

Step on a crack,
Break your mother's back.

Occasionally the sound of cracking ice would echo beneath us. But the ice held.

This mysterious barrier, separating one world from another, has provoked amazement, not least of all in Thoreau himself, who would lie on his belly "on ice only an inch thick, like a skater insect on the surface of the water, and study the bottom at [his] leisure, only two or three inches distant, like a picture behind a glass, and the water is necessarily always smooth then."

Minnesota author and wilderness advocate Sigurd Olson writes of strapping on ice skates when he discovered a sheet of newly formed ice several miles long, beneath shimmering aurora borealis, with "shafts of yellow tinged with green, then masses of evanescence which moved from east to west and back again. Great streamers of bluish white zigzagged like a tremendous trembling curtain from one end of the sky to the other." It is difficult to imagine a more elemental image than the sight of the fragments of creation lighting up the ionosphere and cascading down in reflections on the mirror of pure water in its least energized state. "I had

just come skating down the skyways themselves and had seen the aurora from the inside."

Writer Peter Leschak had a similar transcendent experience, skating along in "a rapidly building sensation of flight—for on clear ice, there is a world beneath your skates, a world of hills, and valleys, and forest of aquatic plants. . . . There are no waves to scatter sunlight, no waves to swirl sediment into clouds." He spied a huge water beetle beneath the ice. "I knocked on the ice with my fist, but there was no reaction—no stopping, no change of pace. We were on opposite sides of a thin but profound barrier—in separate universes. . . . I was like an omniscient but impotent god—able to survey the cosmos, but unable to enter it."

FOR ORGANISMS THAT LIVE UNDERWATER, the skim of ice circumscribes and defines the world in which they live. The formation of ice is the most profound event in the yearly cycle of a lake and the life in it.

Once ice forms, wind has little effect on the water of the lake. Heat loss is greatly reduced. Ice blocks the transfer of gasses between air and water—most importantly, the mixing of oxygen into the surface to replace what is consumed by many organisms in the depths below. Thickening ice and accumulating snow reduce sunlight's penetration to aquatic plants. A four-inch snow pack, regardless of the condition of ice underneath, reflects or absorbs most of the sun's rays. Photosynthesis all but stops, and so does the production of oxygen as a by-product. Meanwhile, organisms from bacteria to fish continue to breathe the dwindling supply of oxygen. Such is the basic equation of winter life: oxygen must outlast ice if life is to survive.

Different species of fish react differently to these stresses. How they cope determines what fishermen can expect to catch during the winter. Species such as lake trout, walleyes, yellow perch, crappies, sunfish, and northern pike remain active and catchable through the winter as long as oxygen remains plentiful. But largemouth bass, and especially smallmouth bass, become nearly dormant. Ice fishermen rarely catch them.

WITH FIRST ICE, fish and other aquatic creatures act as if nothing much has happened, as if the new coating is of little consequence. And why shouldn't they? The skim of ice seals off oxygen from the atmosphere, but there will be oxygen aplenty for weeks or even months. If the ice is clear and snow has not fallen, light

continues to penetrate freely. Aquatic plants may remain green and churn out oxygen. So fish may be found just where anglers left them in late autumn and may be caught just as easily, maybe easier. Because fishing traditionally falls off in late fall, when wind is cold and spray from a running boat stings the face, fish may not have seen a lure for months. For that reason, die-hard ice fishermen greet first ice as eagerly as the opening of the season in spring. First ice is magic, availing the fishermen some of the best sport of the season, and also the power to simply walk on water to their fish.

So within days or (unwisely) hours after a fresh sheet of ice forms, anglers head gingerly onto the lake. In their eagerness, ice fishermen always push their luck. One friend is so excited to start the season, he finds himself walking on ice that bows underfoot. The "continuous cracking and spidering around . . . plays tricks with your mind," he says. Best to carry a set of ice picks, connected by a stout cord worn through your sleeves like idiot mittens. If you fall through, you can claw your way back onto the ice. And it doesn't hurt to wear a life vest if you're really concerned. Most ice fishermen carry an ice chisel four to five feet long and periodically spear the ice in front of them. A friend goes

one better with more elegant equipment. He carries a cordless drill to bore a line of test holes to ensure he steps on at least four inches of good ice, a pretty safe minimum for a single person on foot.

As Ronald Reagan said (though so far as I know, without the benefit of having actually ice fished), "Trust but verify."

(Tom Dickson)

"This is what you meant by a 'cozy weekend getaway in the country'?"

⊡ Snowshoes, Burntside Lake, Minnesota.

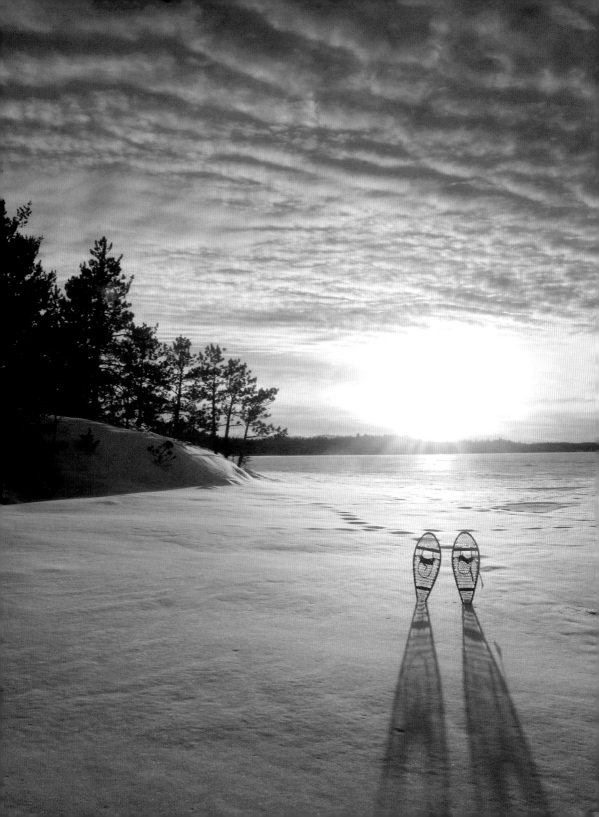

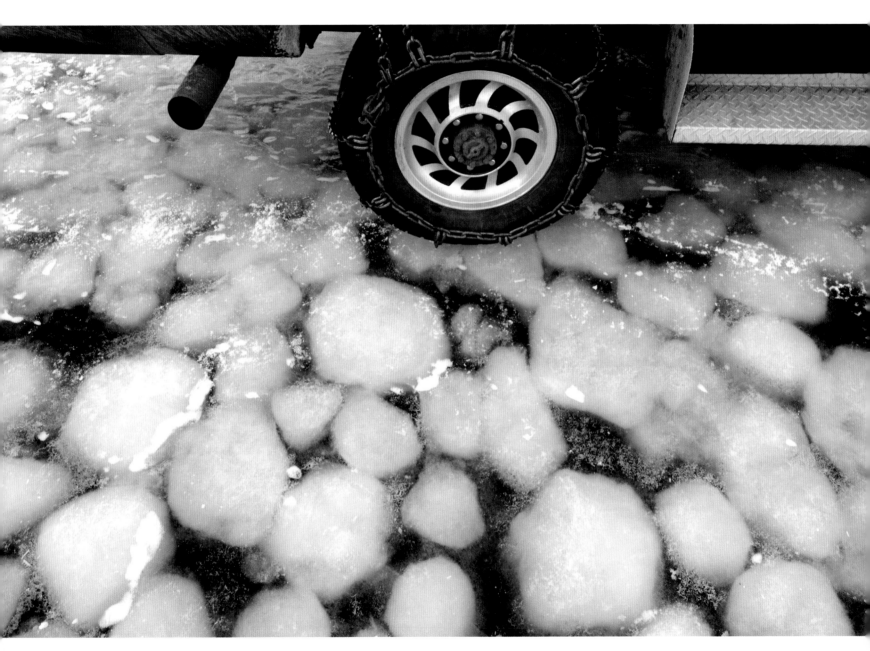

⬆ Tire chains, large bubbles trapped in new ice.

⊡ Sebago Lake, during the Sebago Derby.

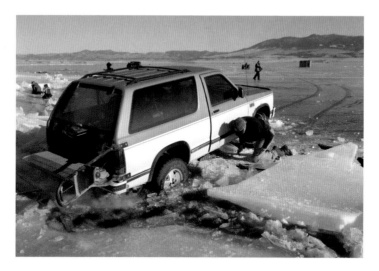

⊡ Second thoughts, Canyon Ferry Reservoir.

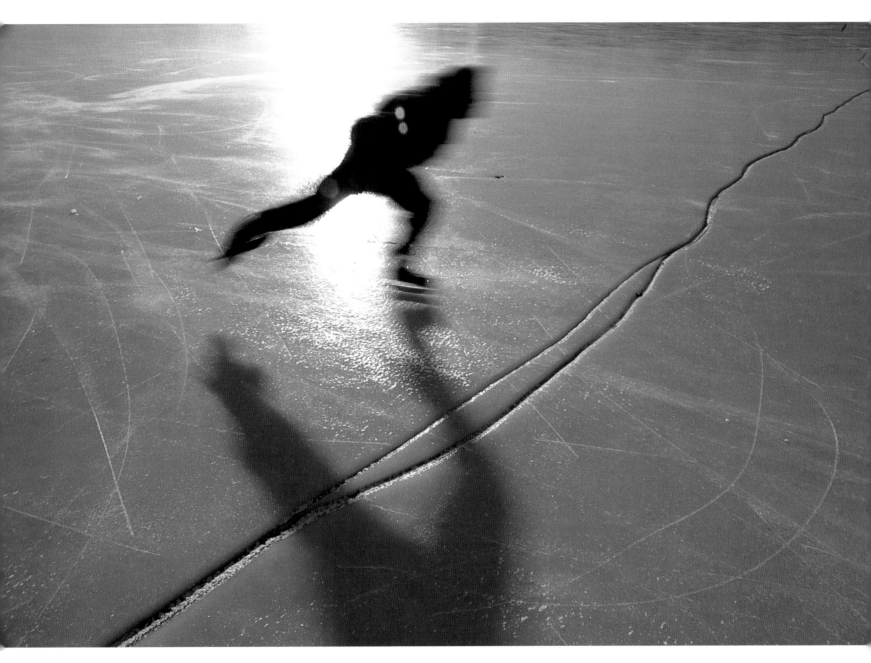

⬆ Lake of the Isles, Minneapolis.

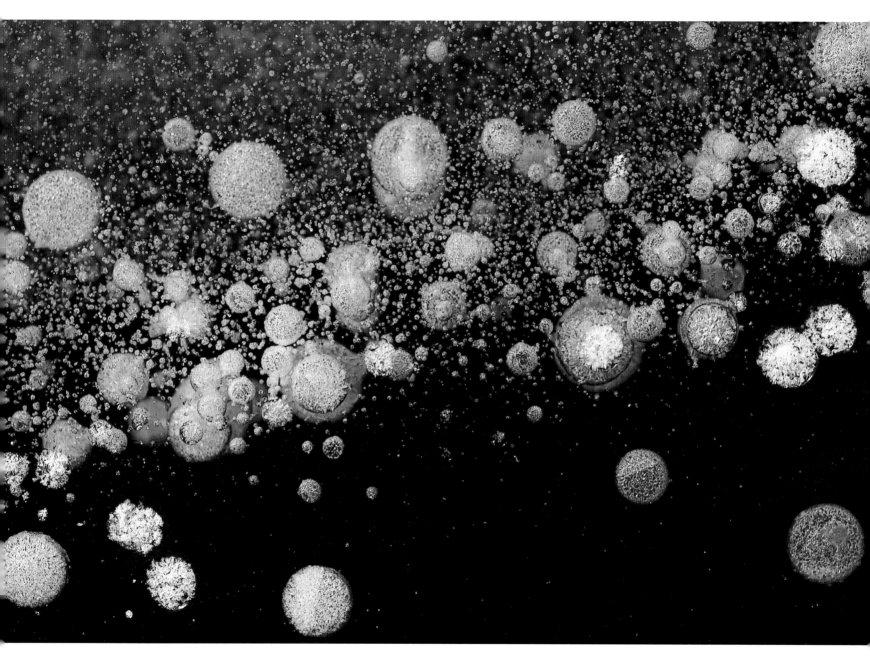

↑ Bubbles, new ice.

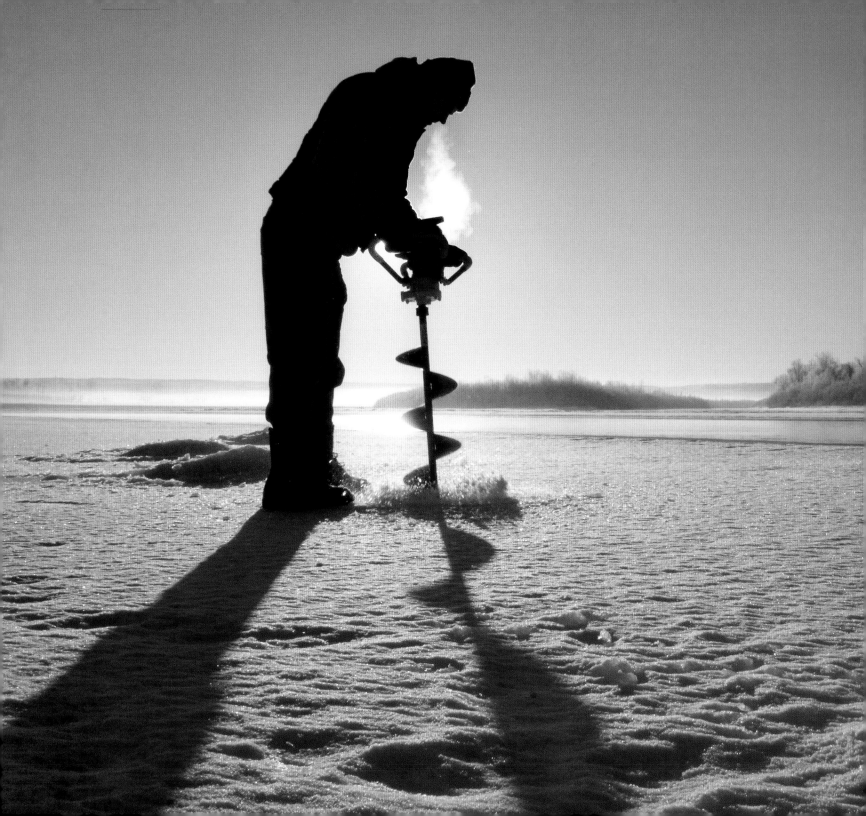

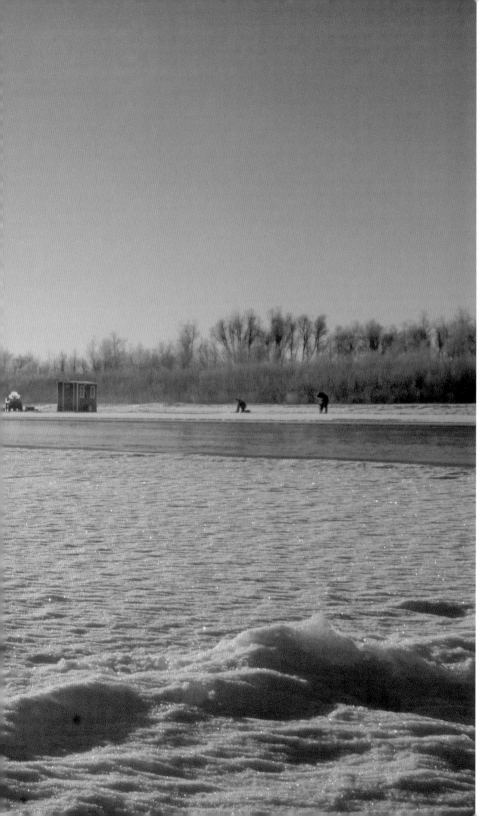

← Drilling near open water, Missouri River
near Williston, North Dakota.

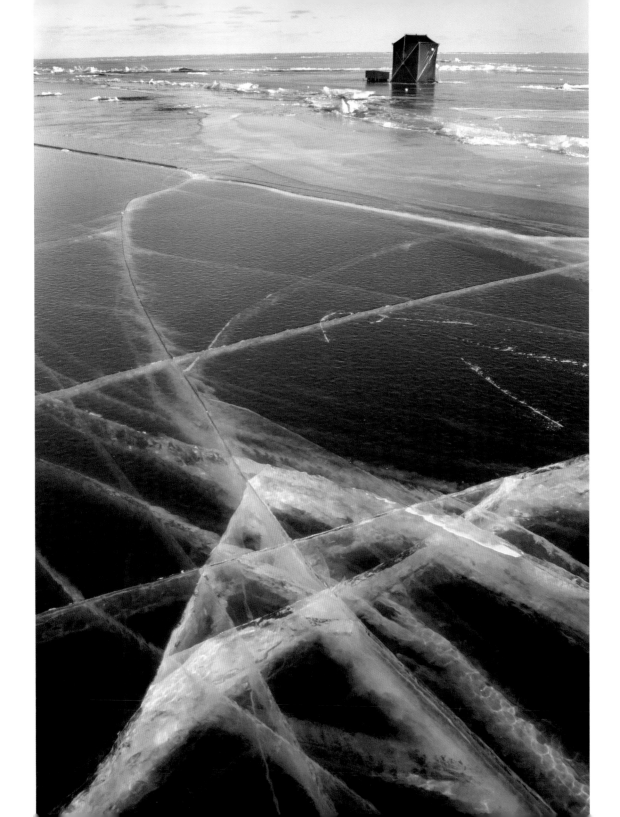

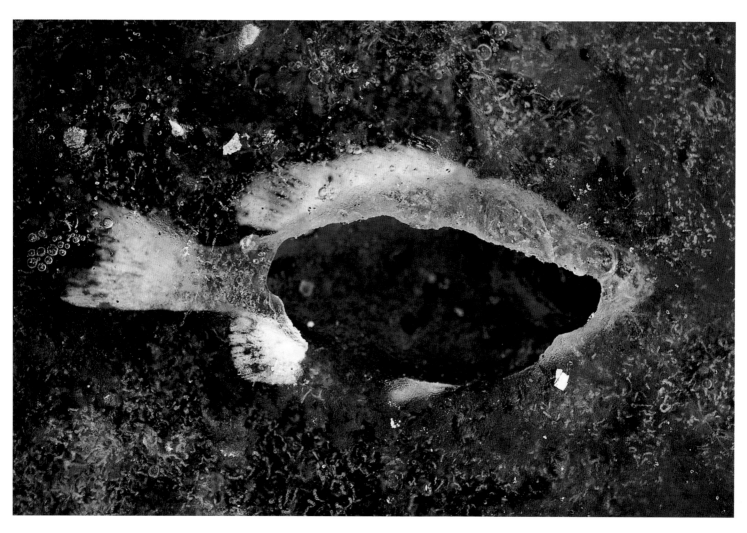

⬆ "Fossil" remaining where birds pecked a dead fish from the ice.

⬅ New ice, Lake Superior, Duluth.

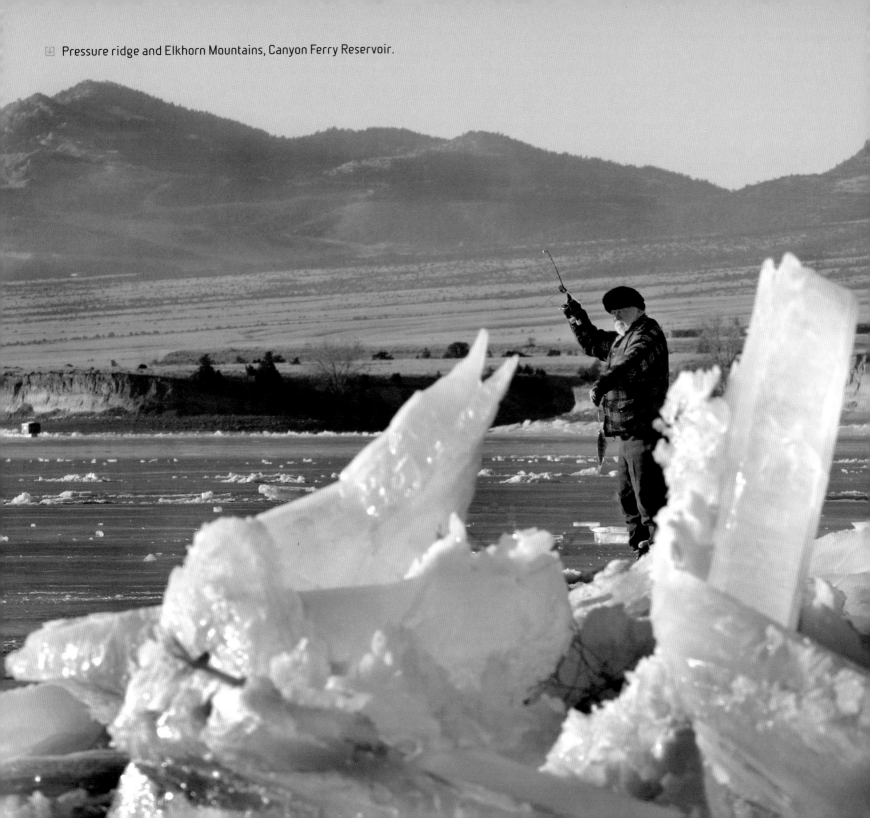

Pressure ridge and Elkhorn Mountains, Canyon Ferry Reservoir.

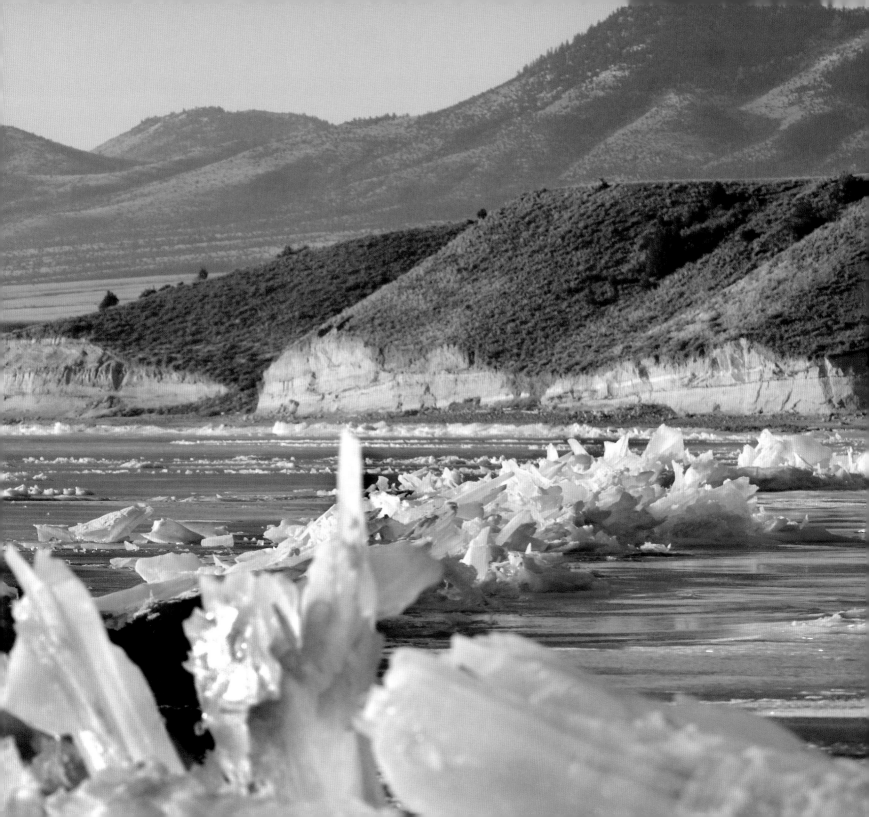

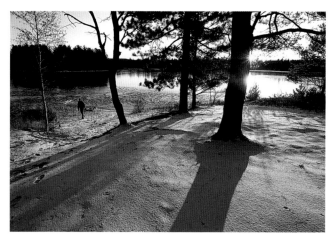

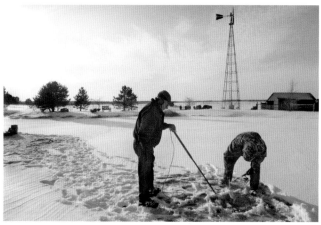

Ice closing up a small lake on Michigan's Upper Peninsula.

Donald Fluhrer and 94-year-old Fred Newton fishing a stocked pond on Fluhrer's bison ranch near Charles City, Iowa.

Winter storm, Kawishiwi River, Minnesota.

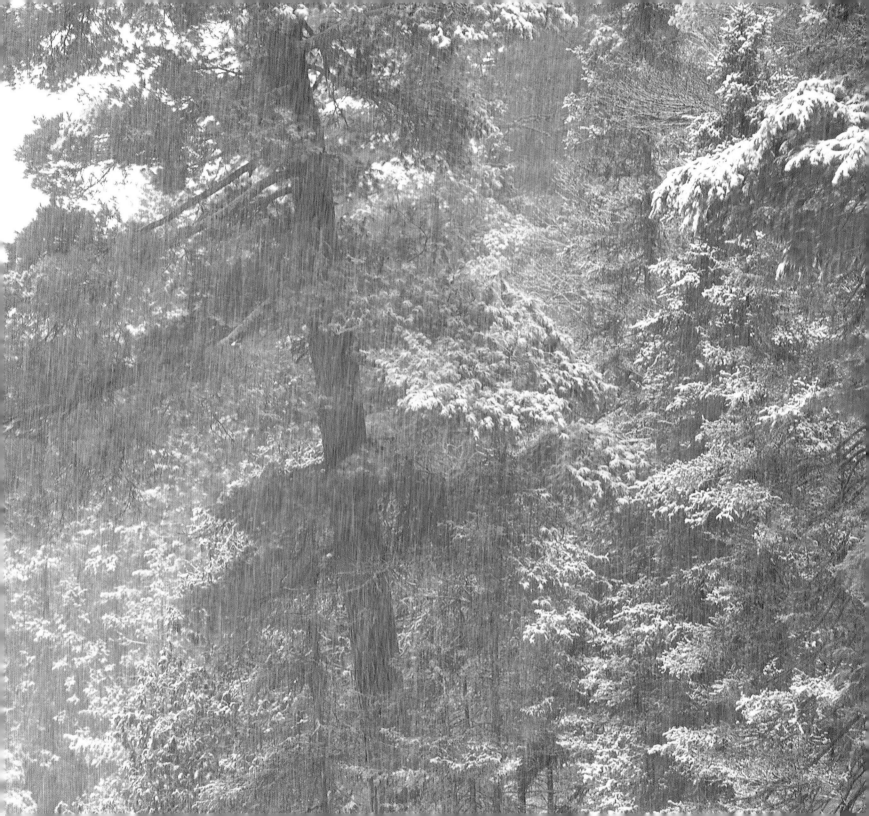

Cities on Ice

Cities on Ice

On our own little lake, after a couple weeks of cold thickens the ice, fish houses erupt like pimples on the pure skin of a young face. Soon, all the familiar places—the weed-covered hump across from our cabin, and the entrances to the two enclosed bays—are covered with a bright rash of shacks.

There is always the question of how early to commit. A big house and the four-wheel-drive pickup towing it onto the ice can run to several tons—not a trivial load. Ice fishing resorts look for a foot-and-a-half of good ice or more before hauling their biggest houses onto a lake.

Ice thickness isn't the only consideration. It helps to have a bit of snow to anchor the houses. Otherwise, they tend to sail around. Sometimes a strong wind will pile them up on the downwind shore. A friend tells me of watching a resort owner trying to corral his wind-blown houses with his pickup.

In Minnesota alone, anglers and resorters will eventually skid more than 150,000 more-or-less permanent houses onto the ice—as permanent as they can be on real estate that remains in existence only about three months. On the best and most popular ice fishing lakes, the clusters of houses will run into the hundreds, creating temporary cities with populations running into the thousands.

Minnesota isn't alone. Depending on the vagaries of weather, of course, something similar happens across the entire North American ice belt.

In New York, anglers will tow houses onto lakes Saratoga, Oneida, and Champlain. In Michigan, shanty towns will form on Houghton, the state's biggest inland lake, and on Higgins, where fisherman camp all night to catch rainbow smelt.

In Ontario, ice "huts," as they're called north of the border, proliferate by the hundreds on Lake Nipissing's

Calendar Bay, North Bay, and near Sturgeon Falls, as weekend walleye warriors spend days at a time on the ice in ever-fancier shacks. "It definitely is the trendsetter when it come to on-ice bungalows," remarked Wil Wegman, an avid ice fisherman who also works for the Ontario Ministry of Natural Resources.

But the ice fishing megalopolis of the East is Lake Simcoe, self-proclaimed ice fishing capital of North America. An open bowl of a lake an hour north of Toronto, it is home to the Canadian Ice Fishing Championship. During the height of winter, as many as 4,000 ice huts appear on the lake, clustered like small towns, as anglers fish for, primarily, yellow perch.

But as popular as Simcoe is, it may be outdone by Minnesota's Mille Lacs, the shallow "walleye factory" of central Minnesota. During prime season, more than 5,000 houses dot the ice, and most are there for the season. The Minnesota Department of Natural Resources takes a census by airplane. "We're counting as we go," said the department's large-lake specialist for Mille Lacs, Tom Jones. Riding in a Cessna 185, Jones flies from village to village, counting by fives and keeping track with a tally counter. "In some places we probably get lost. There's one point near Agate Bay or Hunters Point where they're close together." The location of ice fishing cities depend, first, on the underwater features that provide the best fishing, and second, on access by way of the 200 miles of ice roads plowed by the resorts that ring the lake.

If there is one thing that separates northerners from southerners—something more than politics or food or what side someone's great-grandpappy fought for in the Civil War—it is this business of driving on the ice, lumbering along in a full-sized car, SUV, or pickup truck on a road plowed over the ice. Anyone, North or South, will tell you it is foolish and risky, and only a moron would do it. The difference is, northerners will do it anyway and barely give it a second thought.

But they will keep their windows open and seat belts off, just in case.

Windblown ice.

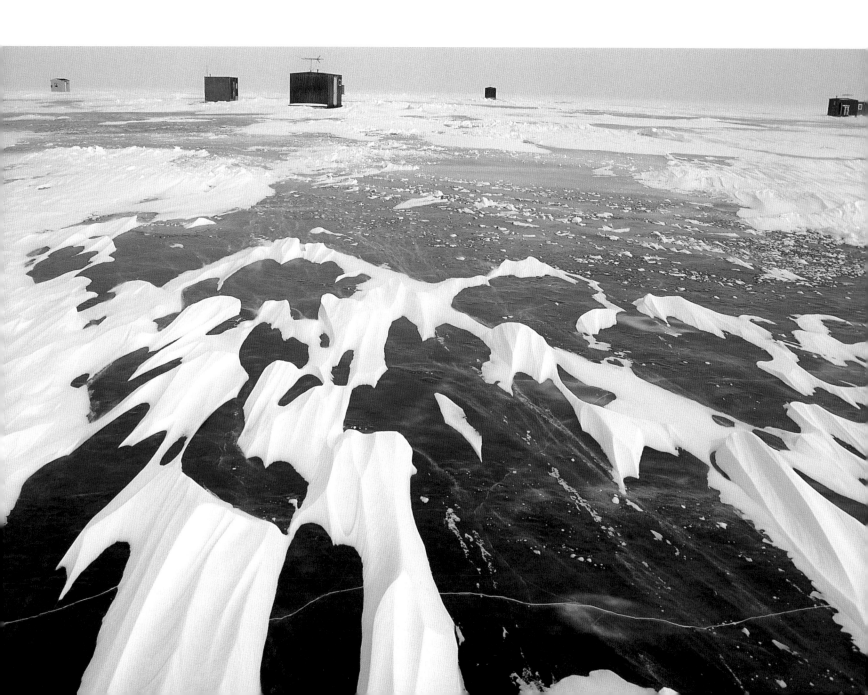

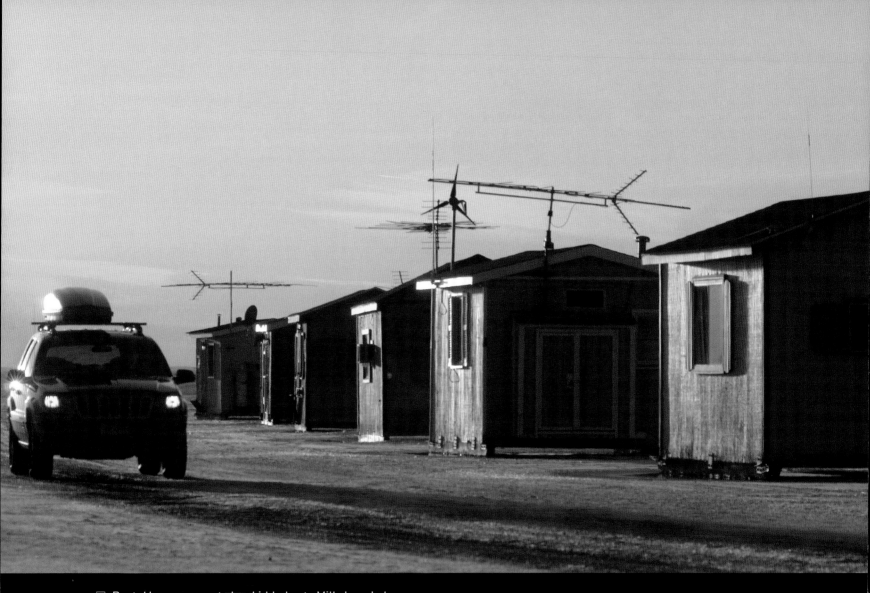

Rental houses, soon to be skidded onto Mille Lacs Lake.

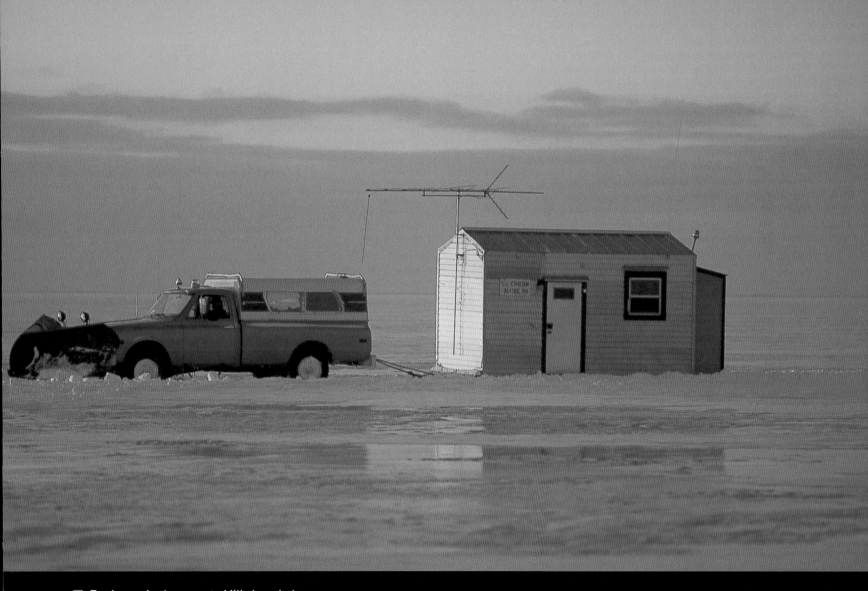

⬆ Towing an ice house onto Mille Lacs Lake.

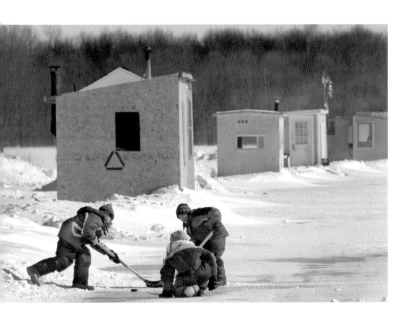

⬆ Action on the ice when fishing is slow, Masson-Angers, Quebec.

➥ Ice houses along a Mille Lacs Lake ice road.

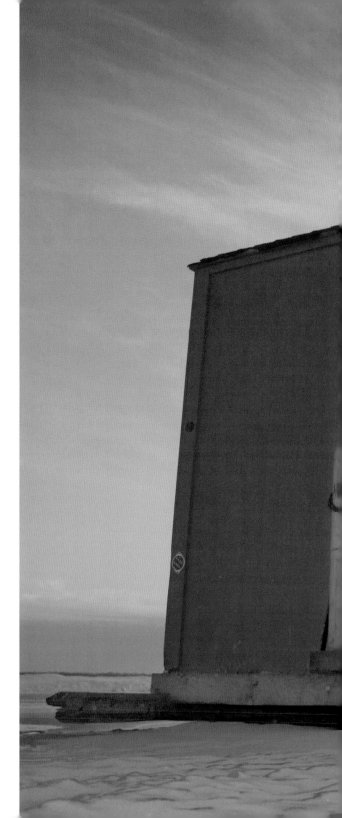

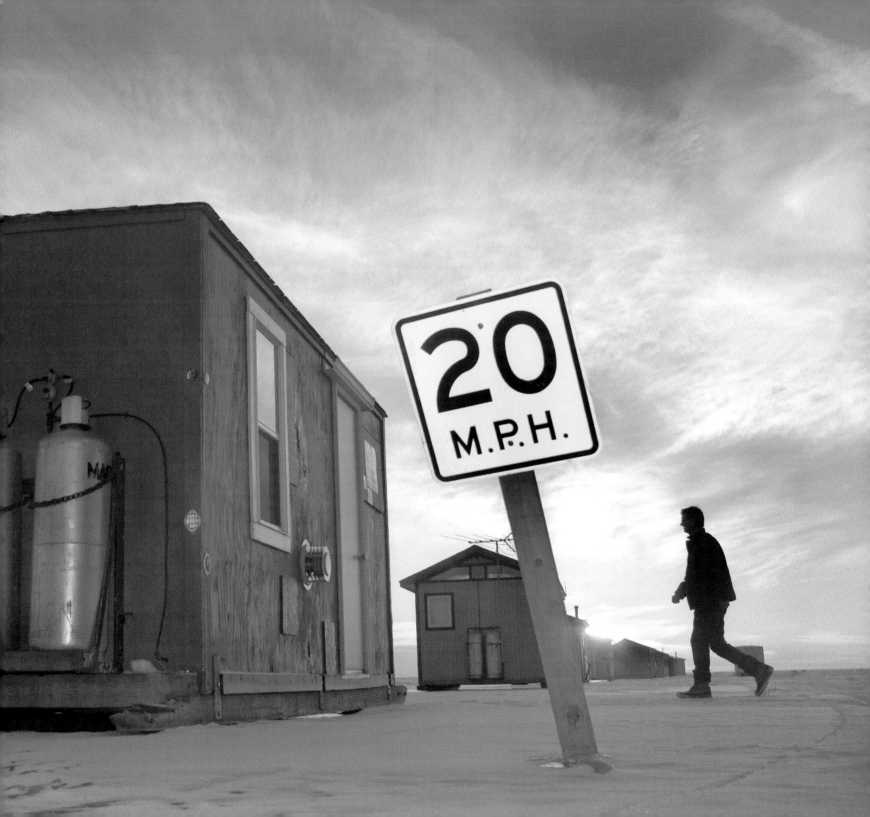

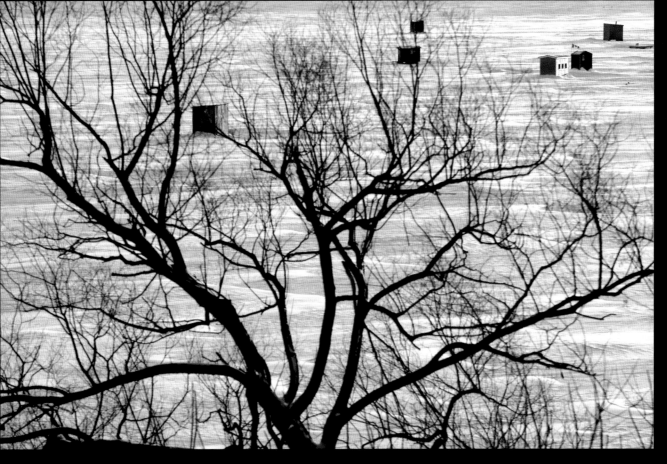

⬆ Muskrat Lake, Cobden.

⮕ Lake Winnebago, ice road in background.

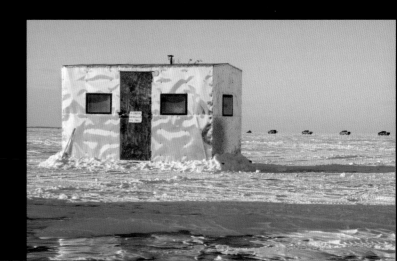

Snow coaches between trips,
Lake Simcoe, north of Toronto.

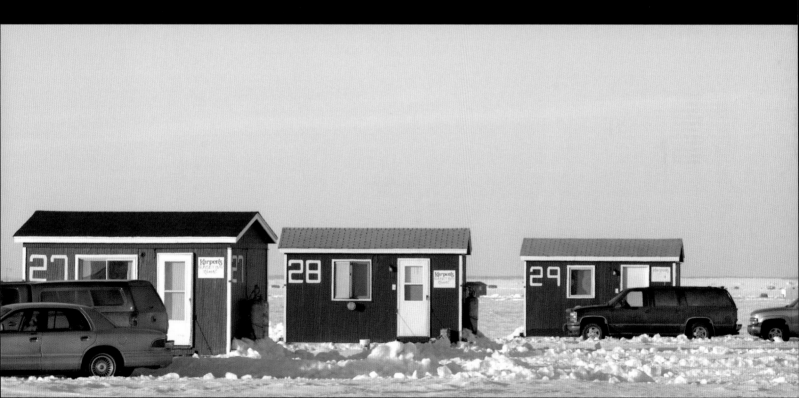

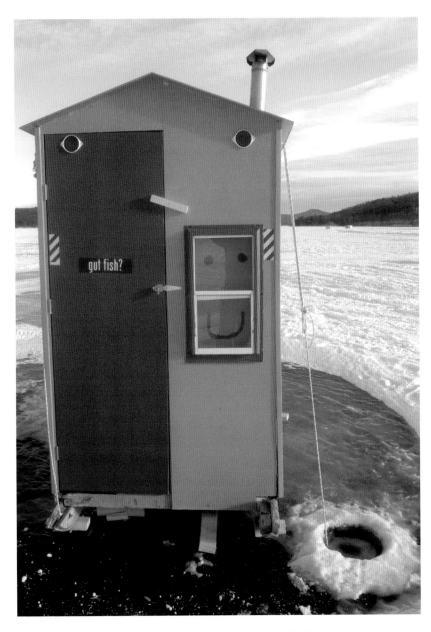

↑ "Bob house" (as shacks are called in New Hampshire) on Lake Winnipesaukee, anchored against the wind.

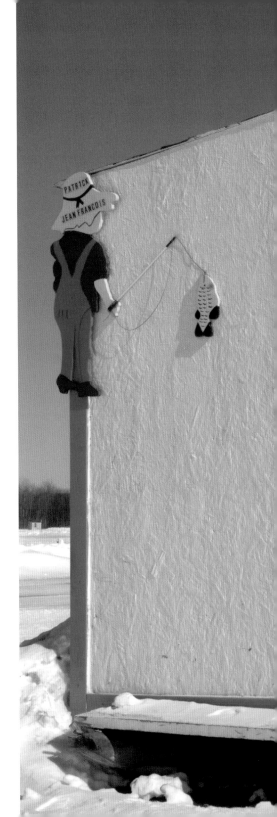

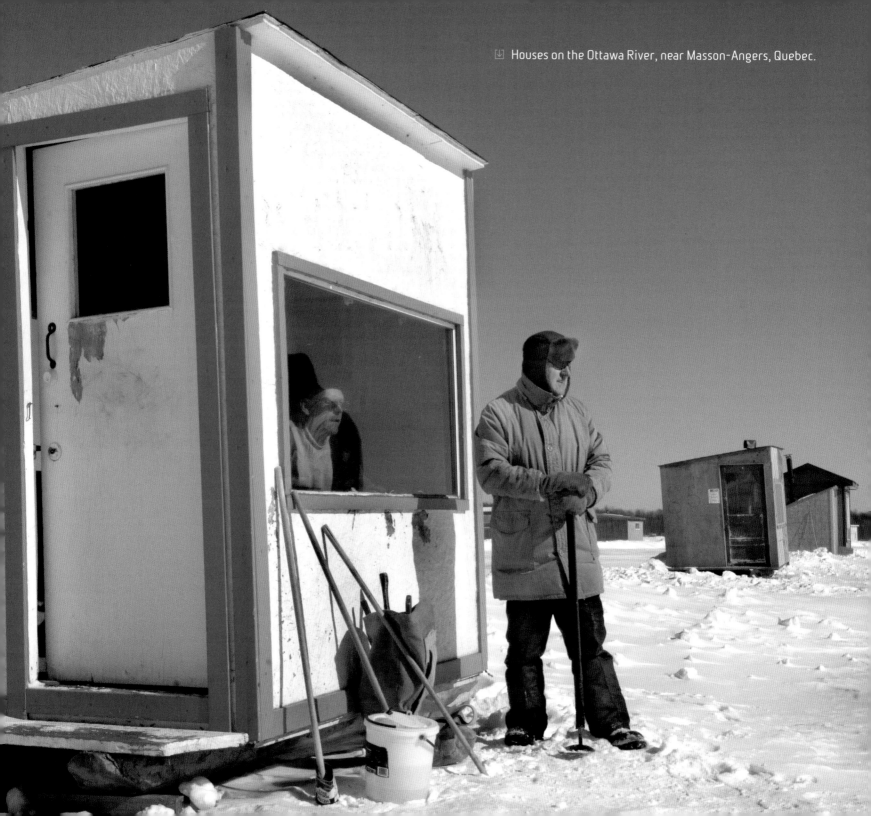

Gearing Up

Gearing Up

As a kid, I didn't go ice fishing often. But it was often enough. I can re-create the experience by examining Dad's old tackle.

A half century ago he used no rods to speak of, only hardwood jigging sticks. About the diameter of broom handles, they were plainly handsome with the grain showing through a coat of hand-worn varnish. Each stick had a couple of pegs on which to wind the extra line. The line itself was braided black or camo, stout enough so you could grab it with your hand to set the hook and haul up a fish. Each rig was finished with a clear nylon leader, a heavy cigar-shaped sinker, and a gracefully tapered wooden bobber the length of a pencil. Other gear included a metal scoop to ladle slush out of the ice hole and a spud or ice chisel, about five feet tall, with a sharp end. The thing weighed several pounds and had a loop on the handle to slip over your wrist so that in your enthusiasm to punch a fishing hole through a foot of ice you didn't lose your grip and harpoon the bottom of the lake.

And enthusiasm you needed—along with bulging muscles and calloused hands, because the spud was a manslayer, a heart-attack machine. You had to lift that weight and throw it down again and again to make any impression at all on the lake. Practically speaking, you busted a new hole with the spud when the ice was a foot or less. Later in the winter, as the ice accumulated from days of subzero cold, you simply hunted up your old ice holes—or someone else's, in hopes they had already done most of your work for you. Once you chopped a hole, by God, you defended that hole from the incursion of cold, chopping and ladling ice periodically to keep it open. One thing you did not want to do, unless the fish absolutely demanded it, was to give up a ready-made hole to go chop a new one. It would be a cold day in hell. And on Earth.

Then there were the clothes. Specifically, the boots. In my case, leather hunting boots with as many socks

stuffed in as would fit. A little later, I got rubber boots with a layer of insulation as thick as a Band-Aid pad. They were not much warmer than the hunting boots and trapped moisture as well. My feet were cold by the time I had walked 100 yards on the ice, and they only grew colder through the day.

Finally, I remember an old steel minnow bucket and the minnows, which always froze in the ice, potential food for the crows once we left.

Because it was such hard work and because it was not very effective, ice fishing really was the sport of oddballs.

RECENTLY I DROPPED IN on the annual St. Paul Ice Fishing Show. If such an event had been held when I was a kid, you could have staged it in someone's living room. A bucket of jigging sticks, an armful of ice spuds, and a dozen ice fishermen don't take up much room. No so today. Billed as the "largest ice fishing show in the United States," the event occupied a big portion of the first floor of the St. Paul convention hall. It was early December of an unseasonably warm year. The lakes, even in much of Minnesota, weren't close to freezing, and die-hard ice anglers roamed the aisles among the new equipment like juvenile delinquents who had nothing better to do.

I discovered (no surprise) that a revolution in gear has transformed ice fishing. Good clothes make winter a technicality. Waterproof, breathable shells keep you warm and dry, whether it's raining or you're sweating. Built-in kneepads protect from cold and water, even as you kneel on the ice rigging tackle, clearing ice holes, and unhooking fish. The clothes, with big zips, are easy on, easy off so you can step into a toasty ice house and strip down in an instant, or zip up and head outside. Neoprene gloves keep hands warm even when wet. Boots promise to keep feet both dry and warm. I saw one pair rated to minus 150 degrees Fahrenheit. I strained to imagine what it even means to have warm toes when it's that cold.

Stubby ice rods with honest-to-god reels and gossamer lines hung in racks by the dozen. Foam bobbers were sold with the promise they wouldn't freeze in the hole. Drop a string of plastic weeds down your ice hole to attract fish to your bait. Phosphorescent ice lures, once charged up, glow for hours. Ice bobbers shine for the whole day and night. Slip phosphorescent sleeves inside your ice hole so you don't step through it in the middle

of the night. Glowing ice hole covers conceal the glowing holes, and glowing reels rattle when a fish is on.

Portable ice houses—Fish Traps and Attack Shacks—flip up in an instant and protect you while you're on the go. Ultra Shack custom fish houses hook up to your trailer hitch. Complete with dining nook, sink, stove, oven, and bunk beds, the whole rig lowers to the ice. "Your imagination," said the ad, "is our blueprint."

The SnoBear is a veritable Abrams tank of ice assault. A three-cylinder engine drives it along at twenty-four miles an hour over ice and snow on Caterpillar treads. Slam on the disc brakes, flip a switch, and hydraulic cylinders snuggle it down to the ice so that it looks like a panther ready to pounce. Pop open the covers, drill holes, and drop your lines.

Dave Genz sat behind a booth. He's been doing these shows and selling ice fishing tackle for two decades. As much as anyone, he's responsible for all this. He has fished his whole life, going out on the ice with his dad, a road construction engineer who didn't work much in winter. Dad fished in his ice house on Mille Lacs through the night, coming home the next morning, Genz said. "How could Mom be mad? He was home every day." Genz, a maintenance engineer for American Linens, was

at work one day, freelancing, welding together a prototype portable fish house from conduit when an engineer walked up and asked, "What are you building there, a fish trap?" Genz had his name—the Fish Trap.

"We're stepping out of the Stone Age and into the Space Age," Genz said. New mapping systems and GPS units can put an ice fisherman on a pinpoint, even if he's surrounded by hundreds of empty acres of ice and snow. Genz began using sawed-off fishing rods to catch fish. Now graphite rods are specially designed for ice fishing. With waterproof, windproof clothes "you can lie down in the snow and take a nap if you want to." Genz is a star of Ice Team University, putting on ice fishing seminars for novices, intermediates, and masters.

Even live baits have changed, as I discovered when I talked to Greg Fisher at Vados Bait and Tackle in the Twin Cities. Mealworm larvae and mousee maggots, long popular for panfish, were augmented by the moth larvae known as wax worms. In the mid-1980s came colorful "Eurolarvae," maggots engineered through dye in their diet and other proprietary factors to achieve a rainbow of baits—red, yellow, bronze, blue-green, and creamy white. All can be ordered over the Internet and shipped express—guaranteed live!

I MAY BE WRONG ABOUT THIS, but I think what changed ice fishing more than anything was the lightweight gas-powered ice auger. Because as long as the ice was more than six inches thick and a man had to rely on brute labor and an ice chisel, he was going to fish the same hole all day long. He might sit there the whole season, reopening the hole each time out. And if it was a no-good hole in a lousy location, that really was beside the point. It was enough that it bridged the gap between man and the world where the fish lived—even if no fish lived nearby.

Even the hand auger left something to be desired. The hand auger looks like a man-sized brace and bit. And it's a huge improvement over the spud for cutting a nifty hole in ice. But even if kept razor sharp and cranked by a strapping young guy with bulging arms, the hand auger has its limits. A friend and I tried punching holes in yard-deep ice with a reasonably sharp hand auger and ended up on our knees, cranking the auger in tandem, exhausted after five minutes. Once we had a couple of holes, we were satisfied to catch potato-chip-sized sunfish for the day.

The first gas-powered augers appeared after World War II, but it was a long time before they were common, cheap, reliable, and lightweight. When they became all those things, in the mid-1980s or so, anglers suddenly became mobile. Now an average guy could slice through a foot of ice in seconds, two feet of ice in less than a minute. And he still had strength enough to jig a rod and battle a perch mano a mano.

As a result, ice fishermen became nearly as mobile as open-water anglers. With depth finders, which anglers discovered could shoot right through the ice, an ambitious crew of anglers could read depths, mark structure, sink three dozen holes, and fish almost as efficiently as guys in a boat. They could return to an exact hot spot with a hand-held GPS and drop an underwater camera down a hole to see if any fish really were around. Then, with walkie-talkies or cell phones, they could ask their buddies, "Catching any?"

Even their feet stayed warm.

ALDO LEOPOLD, in his marvelous essay "Wildlife in American Culture," castigates the sporting goods industry for concocting lots of gewgaws that get between outdoorsmen and the environment. And he gives an earful to sportsmen for letting it happen. "Civilization has so cluttered this elemental man-earth relation with

gadgets and middlemen that awareness of it is growing dim. . . . The sporting goods dealer . . . has draped the American outdoorsman with an infinity of contraptions, all offered as aids to self-reliance, hardihood, woodcraft, or marksmanship, but too often functioning as substitutes for them. Gadgets fill the pockets, they dangle from neck and belt. The overflow fills the auto-trunk, and also the trailer. Each item of outdoor equipment grows light and often better, but the aggregate poundage becomes tonnage."

The ice fishing industry stands guilty as charged. But perhaps there are extenuating circumstances. Because of all the gadgets and contraptions, fishermen have come to better understand what actually happens under the ice—the other side of the mysterious barrier on which they stand. With depth finders and underwater cameras, they can actually see fish congregate along a drop-off, they can detect patches of plankton rising to the surface. Perhaps the sheer educational value has been worth the burden of so much extra stuff. Because as elemental as the experience of ice fishing might have been in the old days, there wasn't much to be learned from freezing one's boots to the ice while staring dumbly down a fishless hole for hours because to move somewhere else was too damn much work.

⊡ Big shoes to fill.

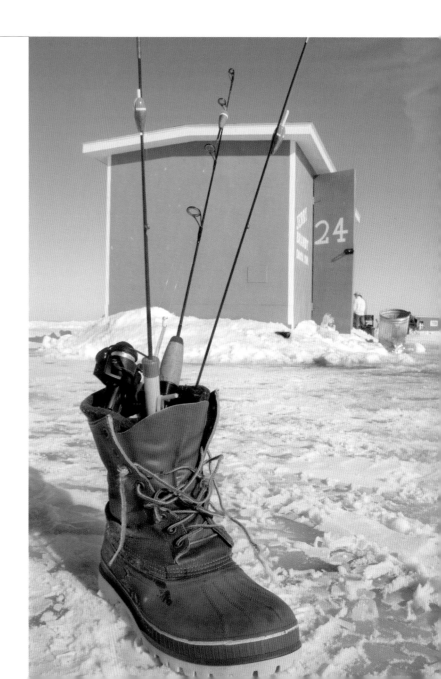

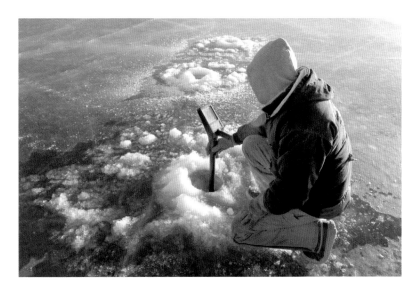

⬆ Plumbing the depths.

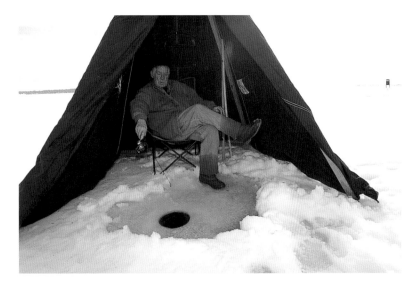

⬆ Effective windbreak, its dark color warming in the sun,
on Lake Superior near Bayfield.

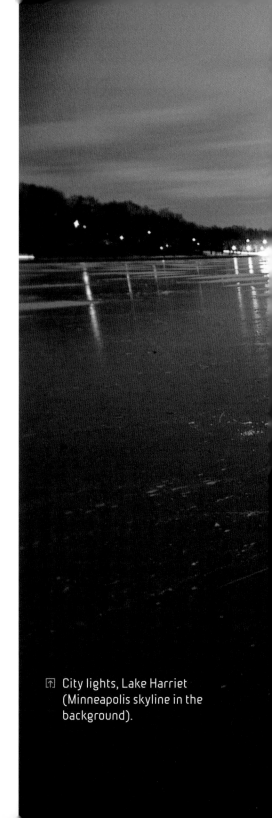

⬆ City lights, Lake Harriet
(Minneapolis skyline in the
background).

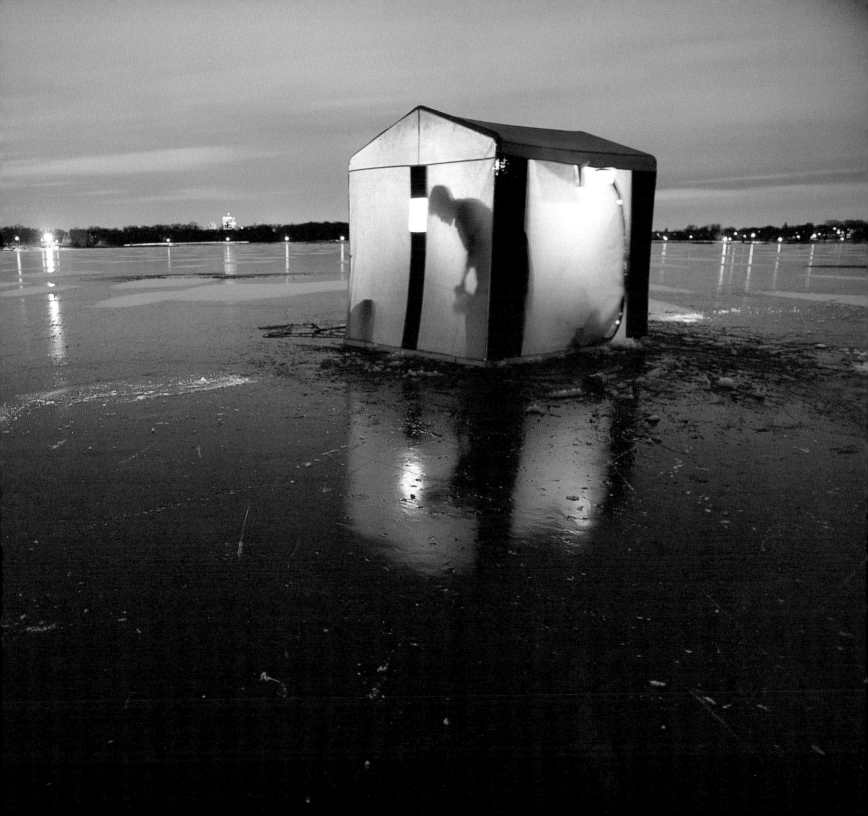

⬆ Minnows and bobber, frozen in plastic bucket.

⬅ Ice fishing jigs.

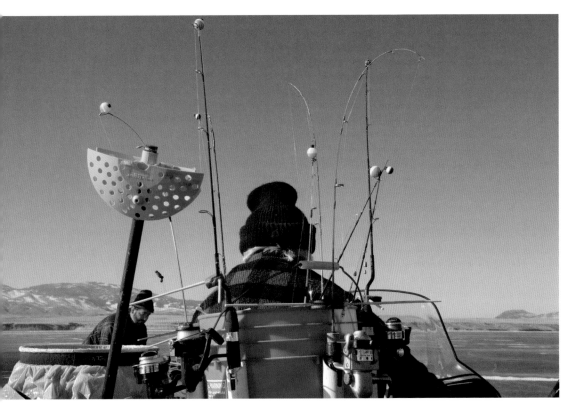

⬆ All-terrain vehicle, ready to fish, Canyon Ferry Reservoir.

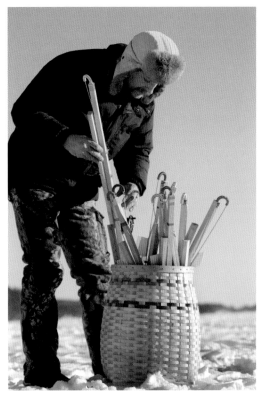

⬆ Chip Manchester packing wooden tip-ups into a handmade pack basket, Sebago Lake.

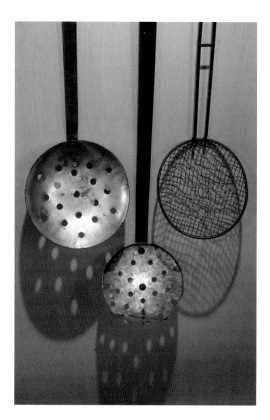

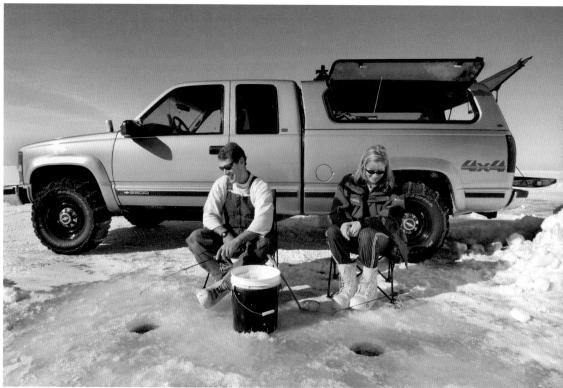

⬆ Ice scoops and minnow net,
Lake Winnipesaukee.

⬆ Transportation as windbreak, Mille Lacs Lake.

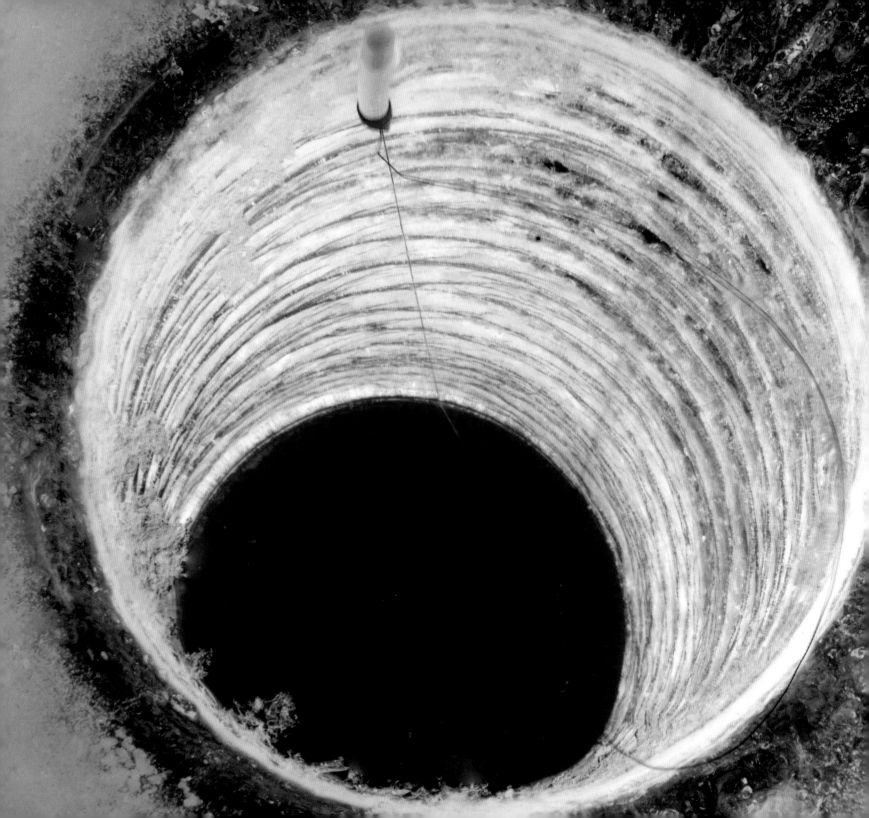

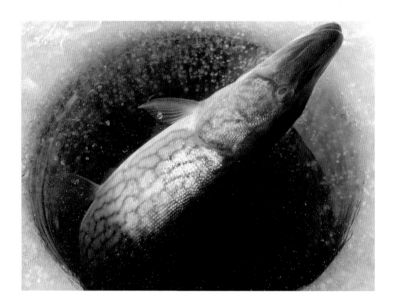

↑ Chain pickerel.

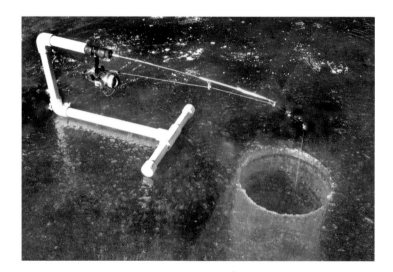

↑ PVC rod holder.

← Auger hole.

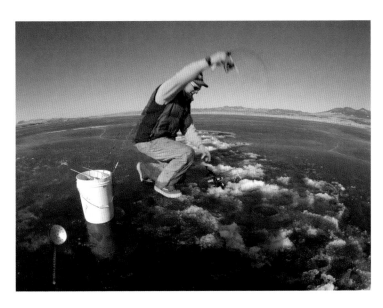

⬆ Fish on! Canyon Ferry Reservoir.

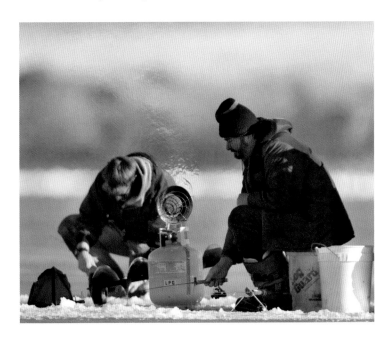

⬆ Heat-seeking anglers, Canyon Ferry Reservoir.

➡ Augers and Elkhorn Mountains.

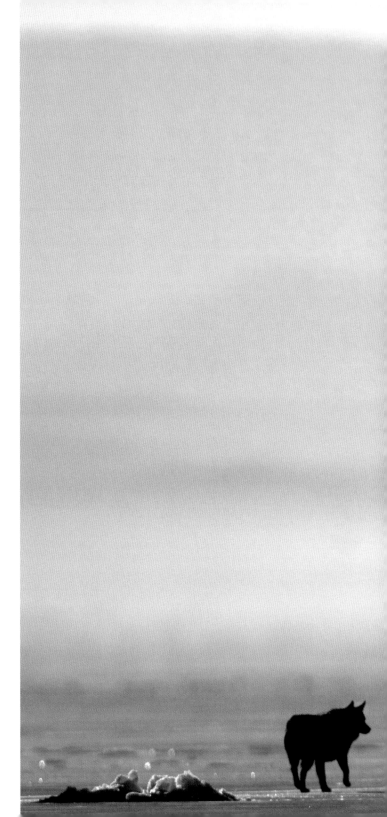

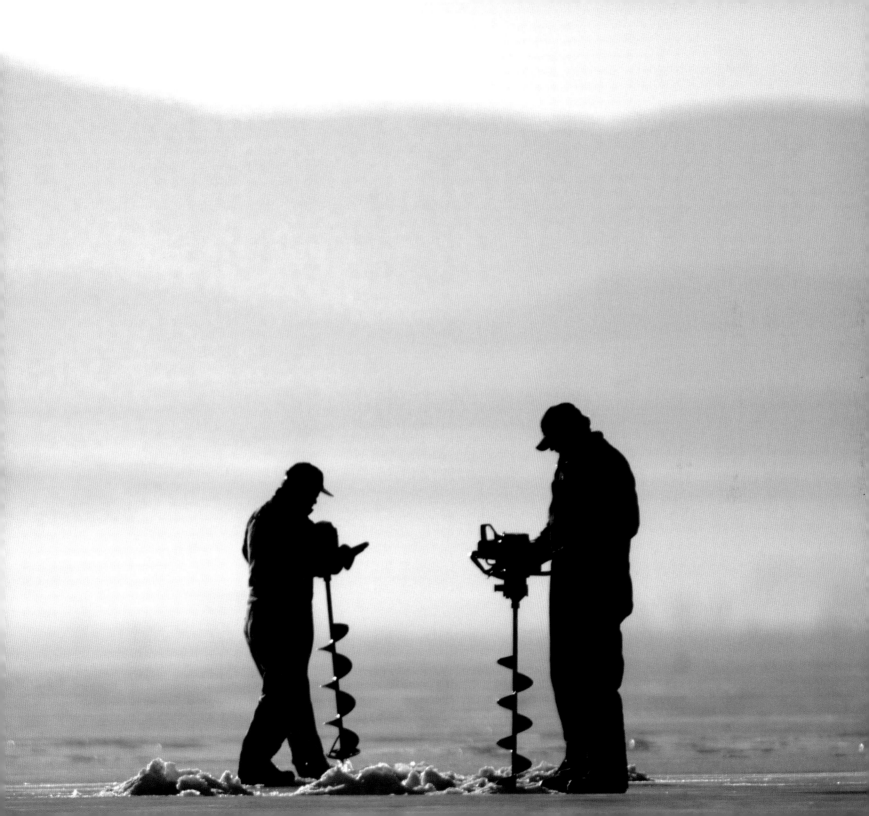

A Home of Their Own

A Home of Their Own

A friend tells the story of visiting other friends on a northern lake. One of his hosts suggested they check out "Bullet" and his ice house. They hiked down to the lake and walked across the ice to Bullet's shack. They knocked, and inside they found Bullet. The floor was

strewn with beer cans. What they did not see was a hole in the ice. Fish were not important, in Bullet's plan. What was important was the house. In Bullet's case, it was a retreat from family, friends, and the world at large.

In ice fishing, a subculture forms around the house, that is, the ice-fishing house, or ice house, or fish house, or shack. They're all the same thing. But in details they vary a lot.

Of course, a lot of ice fishing goes on without houses. At its most basic, ice fishing is a guy with his butt planted on a plastic bucket, huddled against the wind, sighting down a jigging rod into a newly drilled hole. But it does get cold, especially if you plan to spend hours on the ice. And staying overnight, especially on a cold night in January, is out of the question.

In recent years, anglers have taken shelter in portable houses. A fabric-and-frame shack that folds down into its own sled fits with the modern notion of the mobile ice fisherman—on the go at a moment's notice to a new hole, a new bay, a new lake. You can spend hundreds of dollars on a well-designed portable. Or you can improvise. In Russia, I saw a fisherman wrapped up in a huge clear plastic bag. With the sun behind him, the bag glowed like a luminous cocoon. (Or given the Russians' penchant for bestowing the honor of the czar on giant things—the Czar's Bell, the Czar's Cannon—in this case, the Czar's Condom.)

A portable shelter bespeaks a nomadic lifestyle, a lack of commitment or rootedness. And to some folks' way of thinking, a portable shack is no more satisfying

than a Bedouin's tent is to a sense of home. They'll abandon the advantages of mobility for the chance to set down roots on a piece of property, a claim to a place, for at least as long as the ice remains frozen.

The *Boston Globe* reports that ice gives the citizens of the Maine woods access to real estate they never have in summer. Just as Finns have their "everyman's right" to woods and waterways, "when the state freezes over, Maine is returned to Mainers one pond at a time. The waterfront cottages empty out and the laborers who built them are able to travel unhindered over the snow-covered lawns. 'No Trespassing' signs are no match for the colonial-era Great Ponds Act which makes the liquid part of any Maine lake over 10 acres public property."

Most other states in the North grant public rights to "public" or "navigable" waters. But to actually plant a shack on those ponds takes the concept a step further. The ice is the country estate. The house is everyman's castle. "There's a wonderful democracy to it," says my friend, the writer Steve Grooms. "The poorest men, the guys who could never afford anything else, get to have their cabin on the lake." Literally, on the lake. Ephemeral real estate.

The ice angler's version of the country retreat begins with a basic plywood shack with a hole in each corner of the floor. Add a propane stove for warmth and a couple of beds. A cook stove and Porta Potti make long-term habitation more tolerable. A bit of insulation, some wood paneling pulled out of your basement when you remodeled the rec room, and a remnant of garish shag carpet makes it homey. Slap on a coat of paint left over from a recent project. A bright color lifts the spirits. It also helps you find the house in a whiteout.

But like McMansions sprouting in the suburbs, "ice palaces" appear now among clusters of ice shacks—the more popular the lake, the better to be seen. One house, featured in the *New York Times*, sported pine and maple woodwork, satellite TV, sound system, underwater camera, and complete kitchen. Another had a parquet floor of domestic and exotic hardwoods. Some houses reach two stories tall, with plenty of space for the beds, bar, and hot tub. A few years ago, Neiman Marcus, superstore to the wealthy, offered a $27,000 Luxury Ice Fishing House in its Christmas catalog. It was equipped with a steel roof, cedar-shingle siding, vented furnace, carpet and vinyl flooring, a 30-inch cooking stove, a toilet,

built-in queen and double beds, knotty-pine paneling and cedar cabinets, six fishing holes, 120-volt wiring, and a generator. The catalog offered the option of a chandelier and a flat-screen home entertainment system.

Some anglers strike a blow for individual expression, painting an American flag or Peanuts cartoon characters on the side of a shack. Few of us are quite bold enough to do that to a $400,000 house on a suburban lane.

On Medicine Lake, near Minneapolis, some artists are steering ice-house design in a more bohemian direction. The organizers of the Art Shanty Project describe the annual event as "part gallery, part residency and part social experiment, inspired by the tradition of ice fishing and ice fishing houses used in the Minnesota winter." In the past, a plywood post office collected letters for mailing, while a teahouse fish shack with clear plastic walls served cupcakes. The Science Shanty sheltered scientists who offered to explain limnology and life under the ice.

NO LESS THAN the Minnesota Supreme Court has confirmed that "no single word describes the simplicity or the complexity, the amount of space or the lack of space, or the presence of amenities or the lack of amenities that may exist in a fish house."

But the state supreme court? What do the black-robed justices care about ice houses? Quite a lot, actually.

One Marvin Larsen was sitting in his fish house a few years back when a conservation officer knocked, bellowed his presence, and jerked open the door, a seamless effort the court characterized as "barging in." Larsen was fishing with an illegal third line and—*and*—rolling marijuana doobies. He was convicted of both doing and possessing something fishy. But the conviction was overturned on appeal. The supreme court agreed the bust was illegal.

"The range of legitimate activities that can take place in a fish house which people could expect to be private is greater than the range of activities that can reasonably be done privately in a car," wrote the justices. And we know, if we are teenaged or older, the range of activities that can take place in a car. One can only imagine the recreation in a capacious house with beds, hot tub, and a big-screen TV.

But, as the court noted, the luxuriousness of the shack was immaterial. Rich or poor, it was indeed a "dwelling," however temporary. In other words, ruled the court, a man's ice shack is indeed his castle.

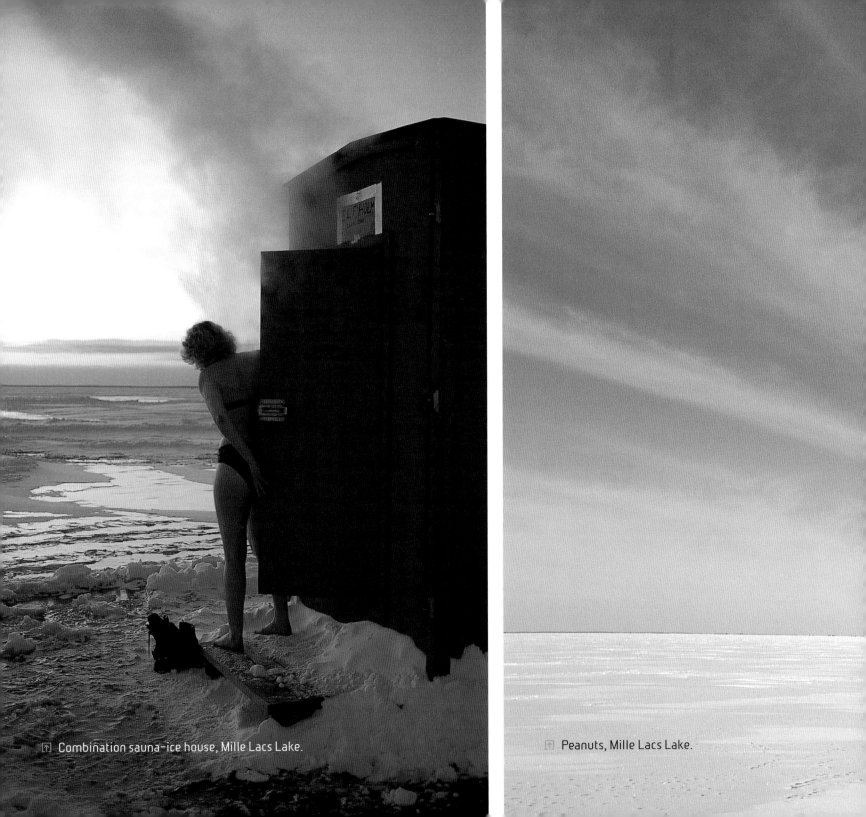

Combination sauna–ice house, Mille Lacs Lake.

Peanuts, Mille Lacs Lake.

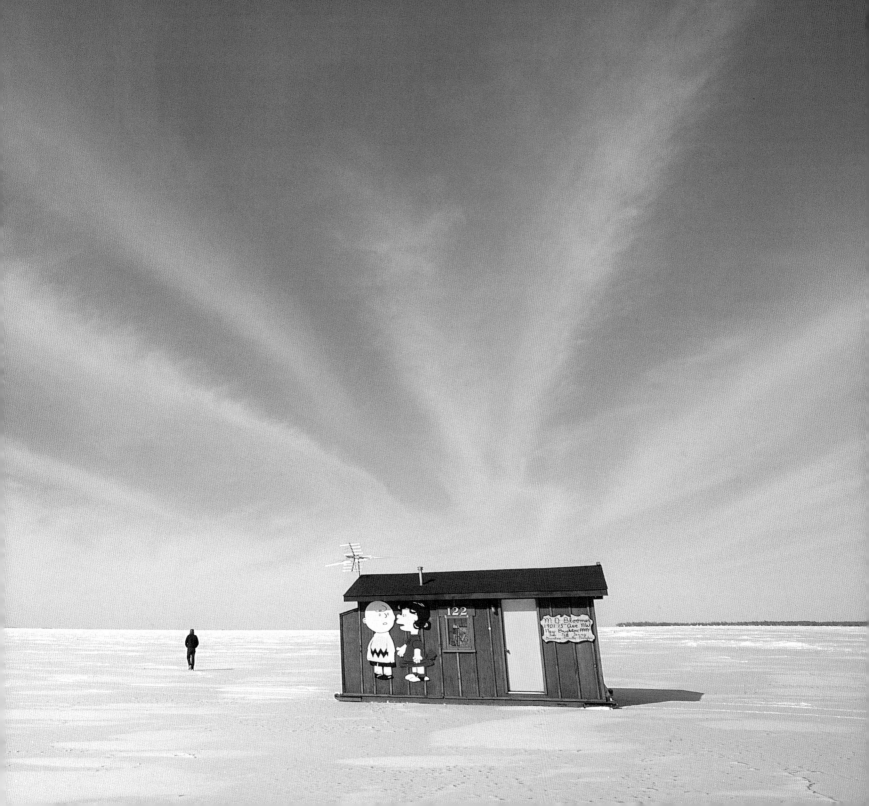

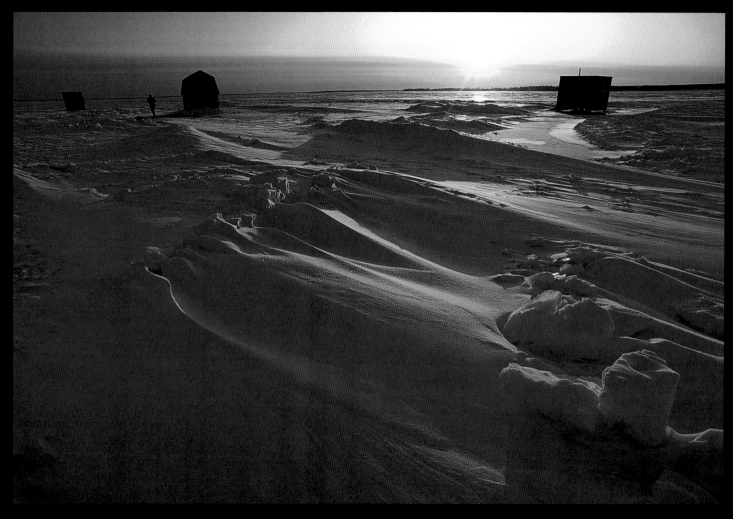

↑ Wind-sculpted drifts.

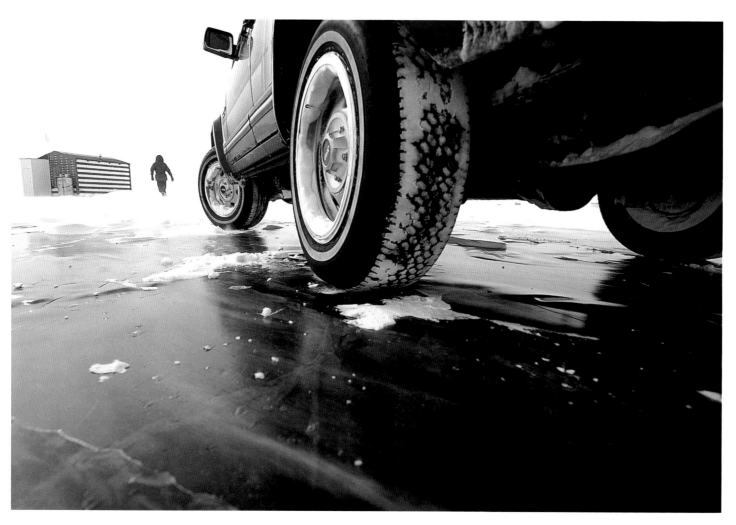

⬆ American scene, Mille Lacs Lake.

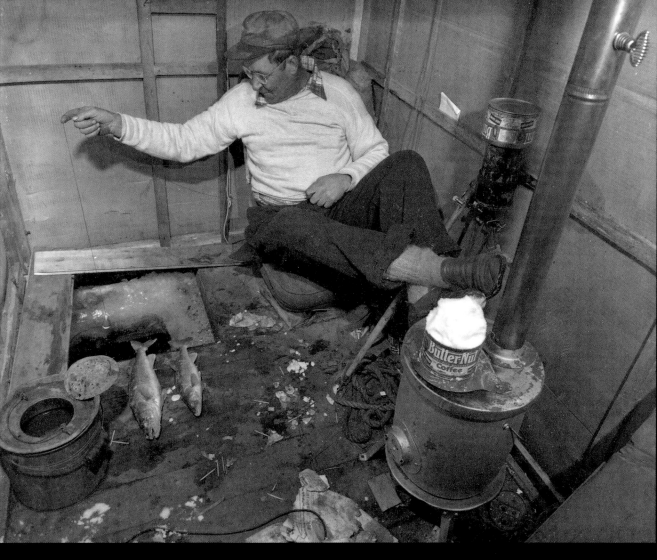

Ice Fishing, Minnesota, 1953. (MINNESOTA HISTORICAL SOCIETY)

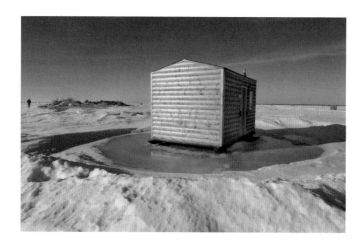

⬆ Log-slab siding, Mille Lacs Lake.

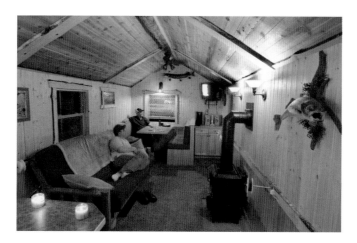

⬆ Mark Rislund's 10 x 28-foot ice house, Mille Lacs Lake.

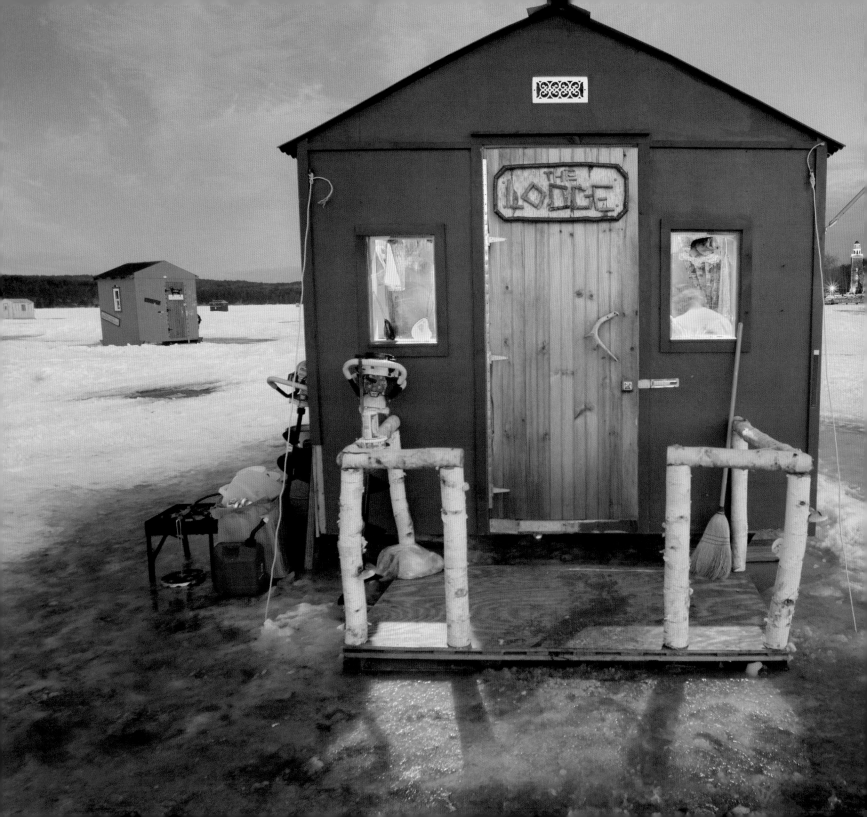

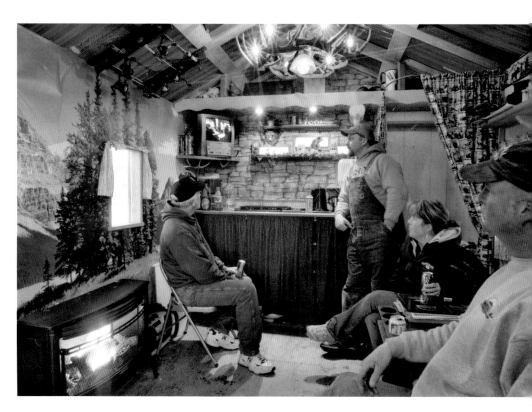

⬆ Holding court in the Lodge.

⬉ The Lodge, a popular spot on Lake Winnipesaukee.

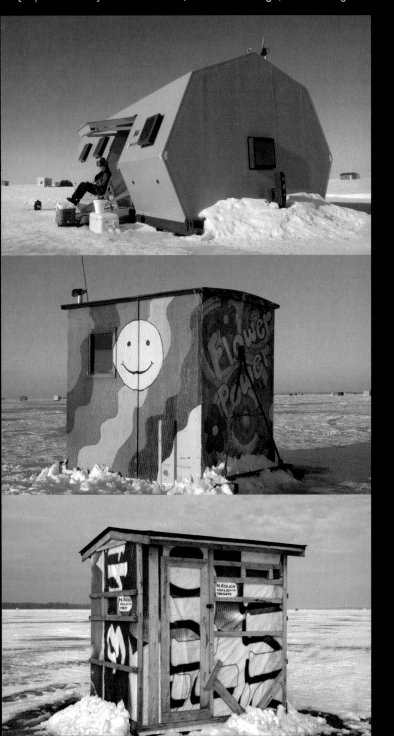

(Top to bottom) Mille Lacs Lake; Lake Winnebago; Lake Michigan.

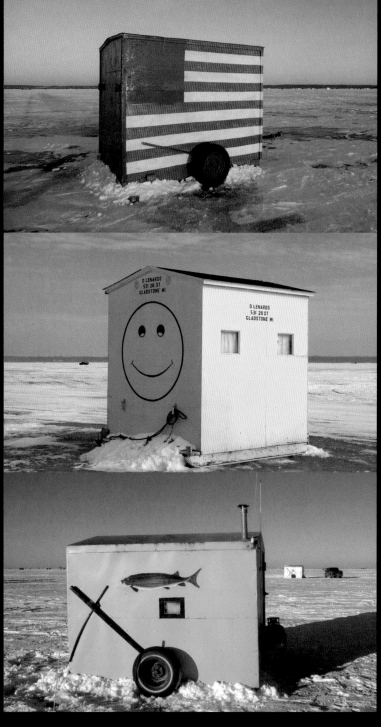

(Top to bottom) Lake Winnebago; Lake Michigan, near Gladstone, Upper Peninsula; Waiting for sturgeon, Lake Winnebago.

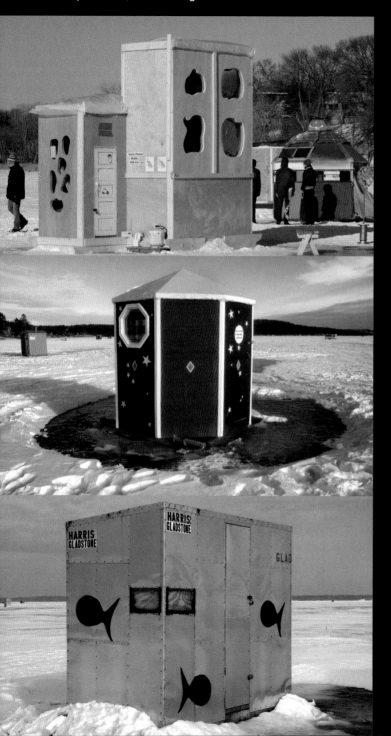

⬇ (Top to bottom) Art Shanty Project, Medicine Lake, Minnesota; Lake Winnipesaukee; Lake Michigan.

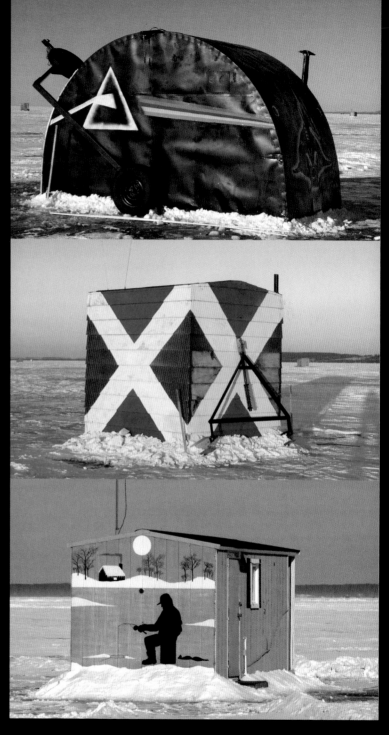

⬆ (Top to bottom) The Dark Side of the Moon, Lake Winnebago; Lake Winnebago; Mille Lacs Lake.

77

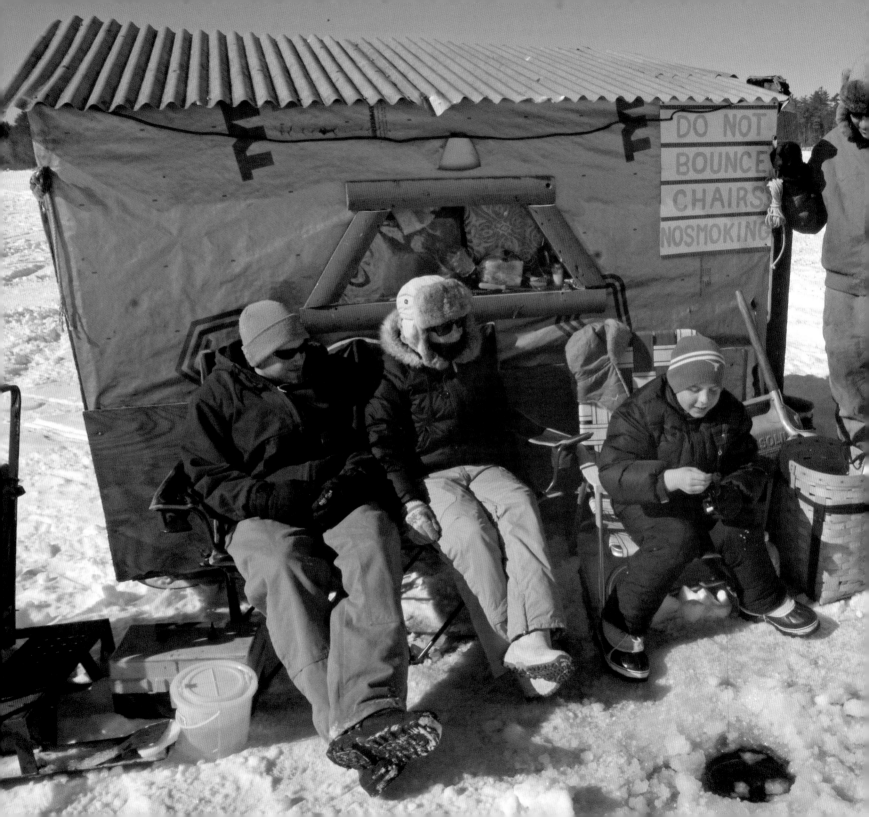

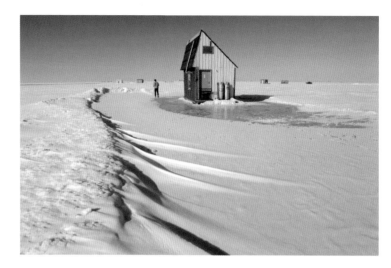

⬆ Complete with sleeping loft, Mille Lacs Lake.

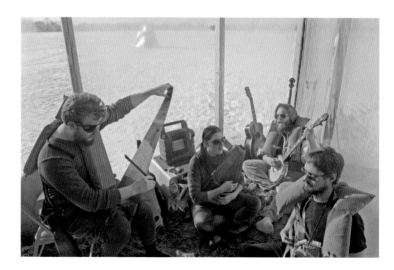

⬆ Art Shanty Project, Medicine Lake, Minnesota.

⬅ Sebago Lake.

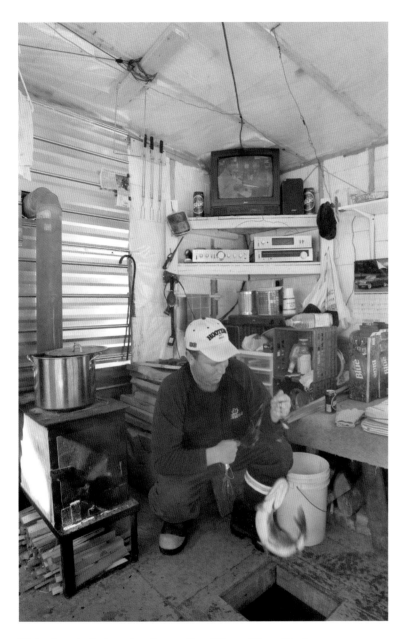

⬆ Ludger Lafortune landing a pike, Ottawa River, Quebec.

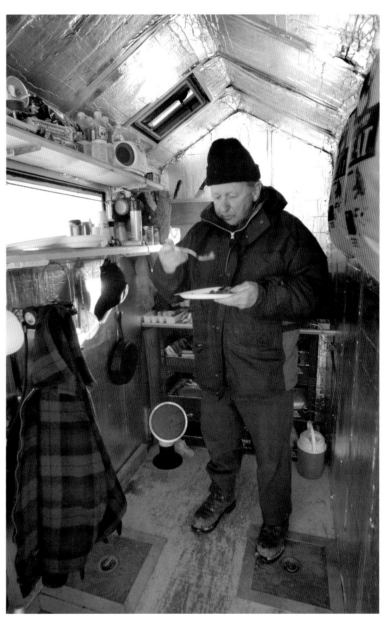

⬆ Chuck Percy, Sebago Lake.

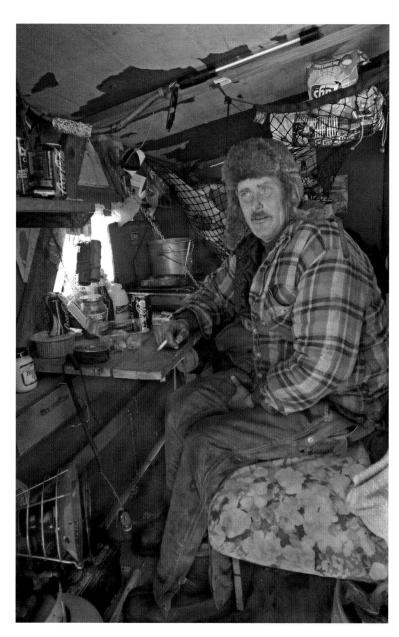

⬆ James Smart, Sebago Lake.

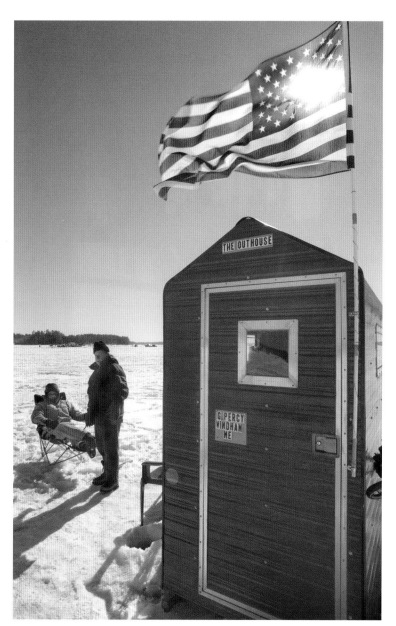

⬆ Sebago Lake.

Into the Wilderness

Into the Wilderness

Last year we ventured far into the Canadian wilderness to catch lake trout. With olive back and silvery flanks, the "laker" surely epitomizes the wild North. And where better to catch them, I thought, than on a lake far from civilization in the wild North, with not so much as

a cabin on a shore of spruce and fir, where the only tracks are likely to be those of moose and your companions.

The morning had begun a nippy minus 25 degrees Fahrenheit at the end of the Gunflint Trail in northeastern Minnesota. We rode two hours by snowmobile, buying our licenses at the Ontario border and continuing up the edge of Quetico Provincial Park until we arrived at our lake. We spent the rest of the morning boring holes, killing minnows, and stamping our feet on the ice. At midday we ate the classic shore lunch—fish fillets and potatoes, fried in many pounds of shortening. The fillets weren't ones we caught; the fishing that day was mostly bad, and we ate the fish our guide had brought along, just in case of such an eventuality. But that's fishing, and it couldn't be helped.

There is something about winter, and by extension, ice fishing, that makes wilderness seem ever the wilder. Perhaps it is the stark beauty of the season, the land drained of color, the pallet of white and gray, tan and black, throwing the conifers in such high contrast that the green of a balsam seems the sign of everlasting life (which indeed it is in the form of a Christmas tree). The simple rigor of traveling in the winter emphasizes the danger and indifference of the wilderness—backcountry travel becomes high adventure in the harsh solitude of winter. Nowhere does such an idea find more vivid expression than in "To Build a Fire."

For those who never have read this Jack London story, "the man"—we know him by no other name—was hiking across the unbroken gloom of the Yukon in the dead of winter. When he spat, the "sharp, explosive

crackle" of his spittle freezing in midair told him it was at least 75 degrees below zero. The man was hiking to a mining camp at a place called Henderson Creek.

Sorry to ruin it for you, but he never made it. He plunged halfway to his knees in a snow-covered spring hole. In his haste to dry out, he built his fire beneath a spruce, which dumped its load of snow, extinguishing the fire. In fumbling with the matches to build a second fire, he scattered them all in the snow. Finally he tried in desperation to grab his dog, slice it open, and plunge his hands into the warm innards to regain use of his fingers. But his hands were so cold as to be useless, and he could do nothing but hold the dog in a bear hug until he relented to a slow but painless death.

THAT IS THE DREAM of adventure that guide Albert Lane peddles—though one can assume that Lane and his clients hope for a different outcome. Lane dispenses with the snow machines and instead travels by dog-sled. Despite the hassle of breaking deep snow for the sleds, of fighting with the dogs (who in turn are fighting with the other dogs), and of hauling dog food by the fifty-pound bag, there is no denying the romance of shushing behind a team, when the only sounds you hear are the footfalls of the dogs, the sibilant hiss of the runners, and your own excited breathing. It is a primitive means of travel to catch fish, a most basic act of subsistence.

Lane lives with his wife and son in a log cabin on a mountain near Carthage, Maine, a town of about 500. There he runs Androscoggin Guide Service. The name itself captures the romance of the Maine guide, of rubber-bottomed boots from L.L. Bean, and wood-and-canvas canoes.

Lane grew up along the river and fished from the time his father, a Maine guide and warden, could carry him in a backpack. Now, in summer, he floats his clients down the Androscoggin to fly-fish for smallmouth bass. In winter he hitches up the dogs. Even here he may be accused of gilding the lily, for his animals, purchased from a Blackfoot owner out West, are wolf hybrids. They are "one-person" dogs, said Lane. No kidding!

Lane runs his dog-wolves along the Benedict Arnold Trail up the middle of twenty-seven-mile-long Flagstaff Lake on the Dead River. Here he parks his team and, if it's windy, cuts blocks of snow from the lake, igloo style, and constructs a semicircular shelter. He drills holes at some distance over the ice and sets out tip-ups

baited with redfin shiners to catch pickerel up to several pounds and perch more than a foot long. One of his dogs, which he describes as "a very smart animal," keeps watch on the tip-ups. The moment a flag springs, she leads Lane to the hole and waits for him to lift the fish. "She'll catch it as it comes out of the hole," he says approvingly.

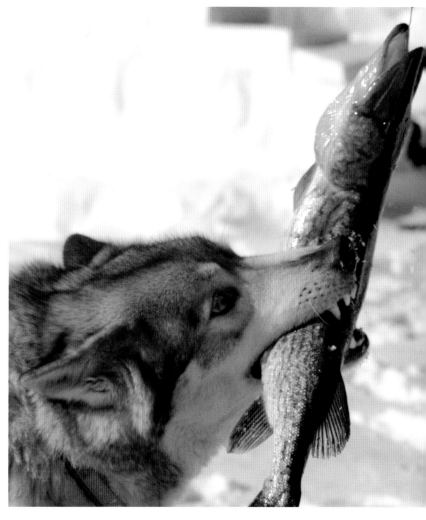

⬆ Landing a pickerel.

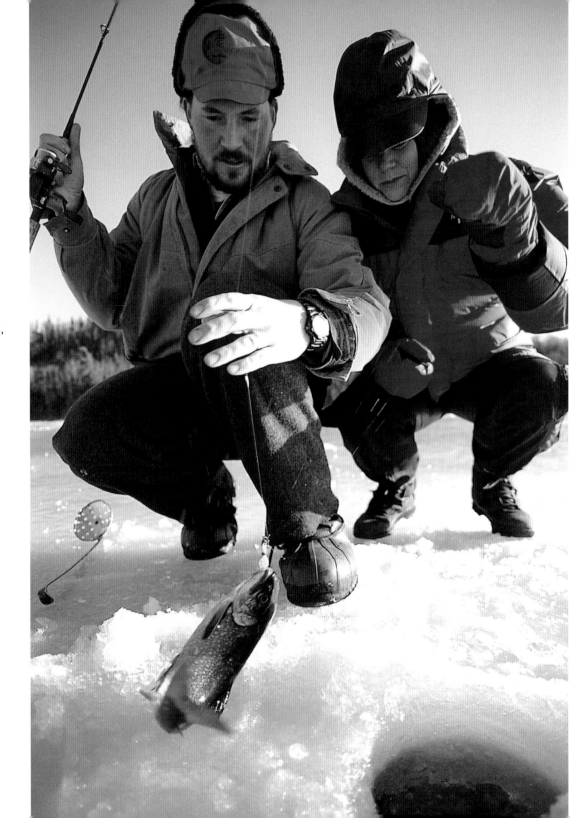

⇥ Fresh lake trout,
Gunflint Lake,
Minnesota.

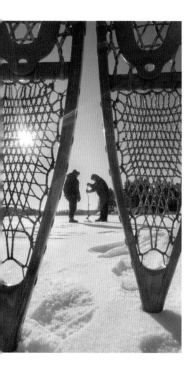

⬆ Lake trout fishing,
Mowe Lake, Ontario.

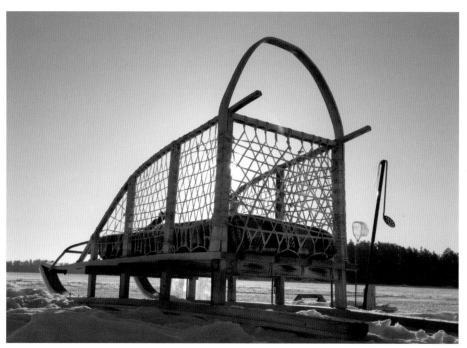

⬆ Empty sled, Saganaga Lake.

⬆ Lake trout, Mowe Lake,
Ontario.

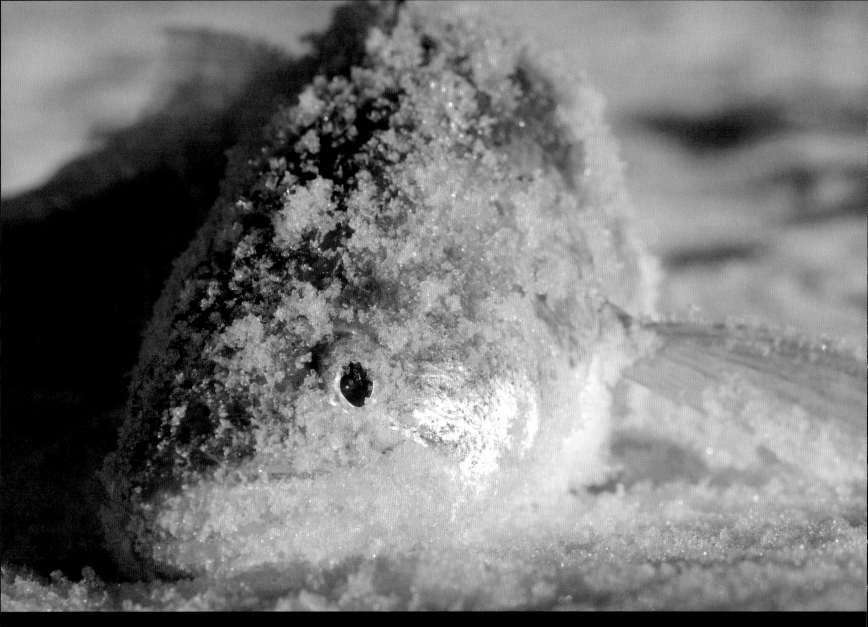

⬆ Yellow perch.

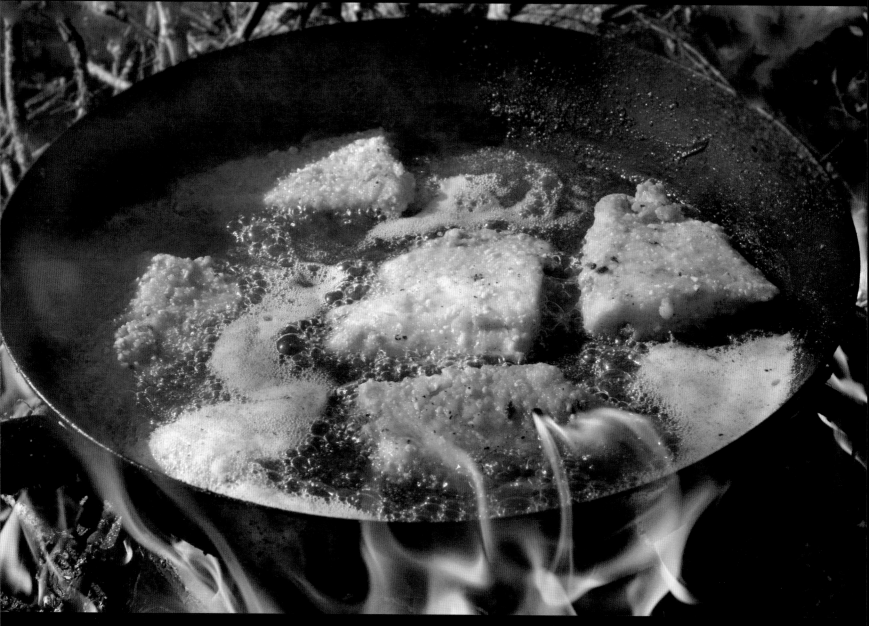

⬆ Shore lunch, Mowe Lake, Ontario.

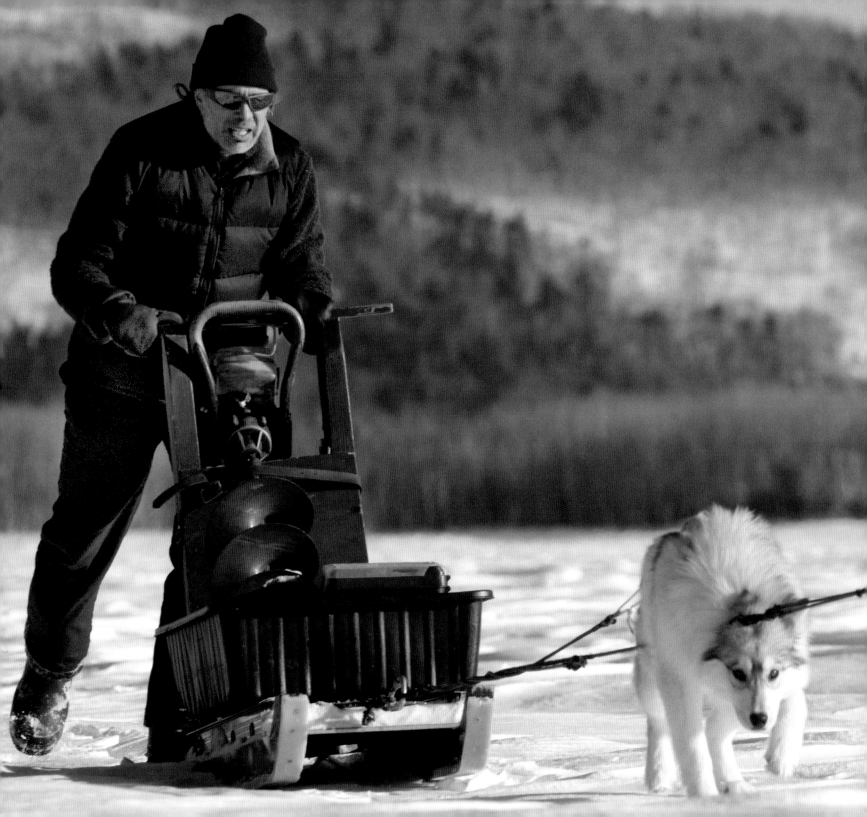

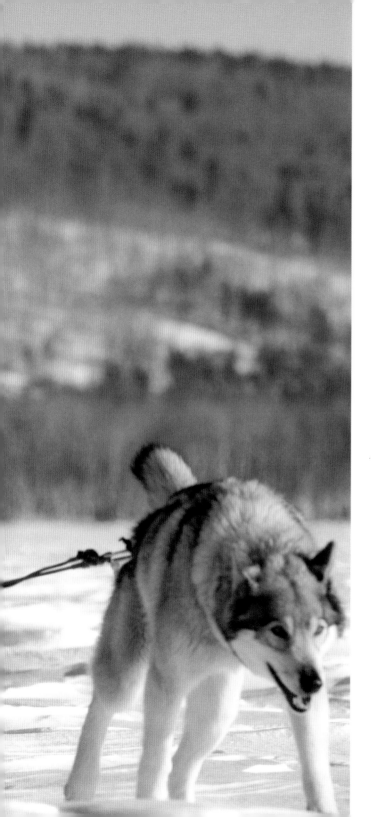

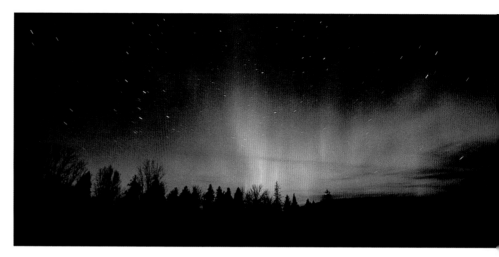

⬆ Northern lights, Kawishiwi River.

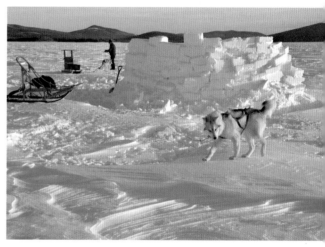

⬆ Albert Lane with pickerel on line, Flagstaff Lake.

⬆ Wind shelter on Flagstaff Lake, Maine (Bigelow Range in background).

⬅ Wolf-dogs pulling Albert Lane, Flagstaff Lake.

Spearing

Spearing

Something magical happens when you chop a big hole in the ice, a really big hole, and then put a windowless shelter over it to block out all the skylight. The hole suddenly becomes a window to the depths below. No, it's more dramatic than that: glowing with all the light

passing downward through the ice and suffusing through the water, the opening becomes Nature's TV set to the aquatic world, a luminous portal through which a patient angler watches copepods, giant water bugs, perch, and, if he is lucky, a large northern pike.

Those who fish in states that allow it will recognize this scene as the basic setup for darkhouse spearing. The fisherman sits in his windowless shack, pitch-black but for the gentle glow from the hole itself. With a stick about the size of a drumstick, he lifts and drops a small decoy fish. Weighted with lead and trimmed with metal fins, the decoy swims a lazy circle several feet down. Occasionally, a pike will race beneath the hole at lightning speed, snatch the decoy and disappear. But if all works right, the pike will glide within striking distance and pause. The fisherman reaches silently for his spear,

propped near the hole, eases it into the water, aligns the barbed tines behind the head of the fish, and smoothly lets it fly.

Spearing is perhaps the most basic, primitive way to take a fish. Except perhaps for a power auger (better for drilling a large hole through thick ice), there is no use for fancy gear. Spearing is more hunting than fishing. For that reason there can be no watching TV or playing cards if the fisherman is to have any success—only the endless attentiveness to the swimming decoy in the glowing hole.

SPEARING NORTHERN PIKE has been outlawed in all but six states, mostly in the Midwest. Even where spearing is legal, its popularity is in decline. It has been bitterly opposed by some anglers who believe, with

some good reason, that spearers are better at taking really large pike.

Yet diehard practitioners persist, especially in hot spots such as Michigan and Minnesota. Bob Johnson, an art teacher at Brainerd High School in north-central Minnesota, so wants spearing to survive as a winter tradition that he teaches a course on the subject, showing his students how to carve their own decoys and use them to attract fish to their spears.

Though spearers normally target northern pike, there are notable exceptions. On Wisconsin's Lake Winnebago and several of the lakes and rivers that flow into it, fishermen spear giant lake sturgeon, some far in excess of 100 pounds. Lake sturgeon were once common throughout the Great Lakes region and Mississippi and Hudson rivers. But dams blocked their spawning runs and pollution destroyed their streams. The Winnebago population is probably the largest remaining. In February, as sturgeon move from Winnebago upstream in advance of spawning, fishermen take them by spearing under a strict quota and a limit of only one fish per person. Fish must measure at least a yard long. When the quota of about 1,000 is met, the season closes.

Still, it's a circus. As many as 12,000 spearers buy licenses. Up to 5,000 dark houses are out on the ice at a time. Spearers attempt to "decoy" the fish with lures that look nothing like their food. Sturgeon are bottom feeders. Their tubelike mouths suck up worms and crustaceans. But the decoys include such odd objects as slowly twirling bowling pins, model airplanes, and even disco mirror balls.

OJIBWE INDIANS retain the right to regulate their own hunting and fishing on some lands they ceded to the United States in the 1800s. On Wisconsin's Lac du Flambeau, Ojibwe legally spear walleye and muskies as well as pike. Some spearers still practice traditional methods, lying on conifer boughs, covering their head and shoulders with a blanket thrown over a small tipi frame. Many years ago, I talked to Lac du Flambeau spearer and carver Ben Chosa. I admired a graceful decoy of natural wood, colored only by smudges of charcoal.

"It swam well enough to kill me a lot of muskies," Chosa said. "They are designed to decoy a muskie to within range of a hand-held spear so you can take that

muskie to feed your family. That it's artistically pleasing to somebody is incidental."

Yet the aesthetics of ice fishing decoys—"fish" in the vernacular of carvers and collectors—are hardly incidental to others. Their appeal will endure even if spearing itself becomes a relic of the past

The earliest-known decoys are Inuit. Some carved of walrus ivory date back 1,000 years. How spearing fish through the ice began is an answer lost to time, but in 1763 fur trader Alexander Henry reported that the Ojibwe near Fort Mackinac jigged lead-weighted decoys beneath huts of sticks and skins to lure trout within range of a spear. The spearer, Henry wrote, "lets down a figure of a fish carved in wood and filled with lead. Round the middle of the fish-effigy is tied a small packthread; when at the depth of ten fathoms [an incredible depth for spearing], where it is intended to be employed, it is made, by drawing the string and by the simultaneous pressure of the water, to move forward after the manner of a real fish." Frances Densmore in *Chippewa Customs* described Ojibwe decoys with tails of birch bark.

Explorers and settlers learned the skill from these woodland Indians. By the end of the 1800s, the sport was firmly established around the Great Lakes and in rural New York. A cottage industry of decoy-carving blossomed during the 1920s and 1930s, its epicenter in Michigan. Hans Janner, Sr., of St. Clement, perhaps the most celebrated carver of all, fashioned muscular fish with broad tails, painted in sometimes fanciful colors. His son, Augie, fashioned decoys with ghostly eyes. Oscar Peterson, a Cadillac, Michigan, carver, made long curved fish with cartoon features and Art Deco flair. Yock Meldrum's straightforward fish were prized for their efficacy as much as their design. Minnesota decoys, such as those carved by William Faue, are known for bright, contrasting colors, which perhaps worked best in the bog-stained lakes of the North or turbid lakes of the prairies. Minnesota spearers also carved critter decoys—frogs, mice, and even beavers.

To this day, carvers whittle and paint distinctive fish. Some are realistic; others, fantastic. Zygmund Obidzinski has carved a delicately hued sucker minnow with an elegant matching jigging stick. Harley Ragan's "tiger trout" has beautiful stripes and red fins with white-trimmed leading edges. It looks as though it could swim away and be the most beautiful fish in the lake.

Though many of these fish, at least in the early days, were made to be fished, you'd never wet one today for fear a northern might actually make a pass at it. Fish by Janner Sr. and Peterson have fetched nearly $20,000 at auction. The decoys have become valuable enough that unscrupulous carvers and dealers are fashioning and selling fraudulent Petersons and Faues, with artificially weathered paint and intentionally rusted fins.

The value of decoys old and new has raised another issue—not an ethical one, but a philosophical one. Should a decoy be more highly prized if it was carved to catch fish and valued less if it was carved for the collector? Jim Richards, a collector from Detroit Lakes, Minnesota, thinks so. He prefers his fish "honest," carved for use, with peculiar touches added not to please a buyer but out of the carver's own whimsy. "These are folk art," Richards said of fish made by fishermen themselves. "They weren't made for the market."

(Clockwise from right) Lac du Flambeau carver Ben Chosa holding his working decoy; decoy by unknown carver (JIM AND MARY RICHARDS COLLECTION); decoy carved by Oscar Peterson, Cadillac, Michigan (ART KIMBALL COLLECTION); decoys (JIM AND MARY RICHARDS COLLECTION); Ben Chosa decoy and jigging stick.

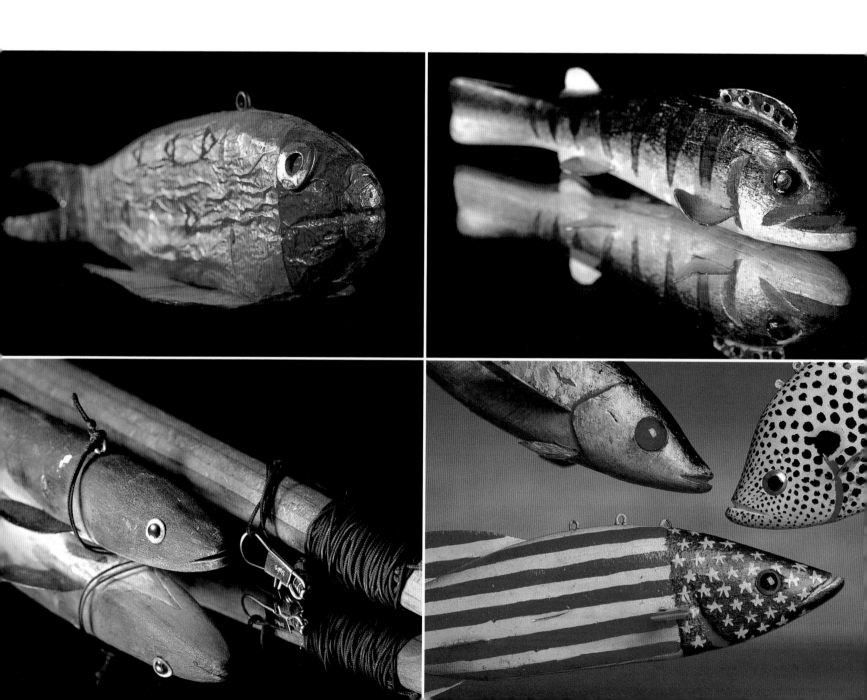

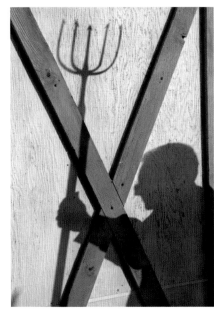

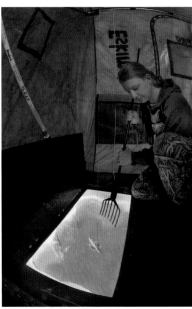

⬆ (Clockwise from top) Ron Meyer, Lake Winnebago; Sandy Hagen, Buffalo Lake, North Dakota; Fish spear, Galena, Illinois.

➡ Bruce Sheely, with poised spears and decoy, Lake Winnebago.

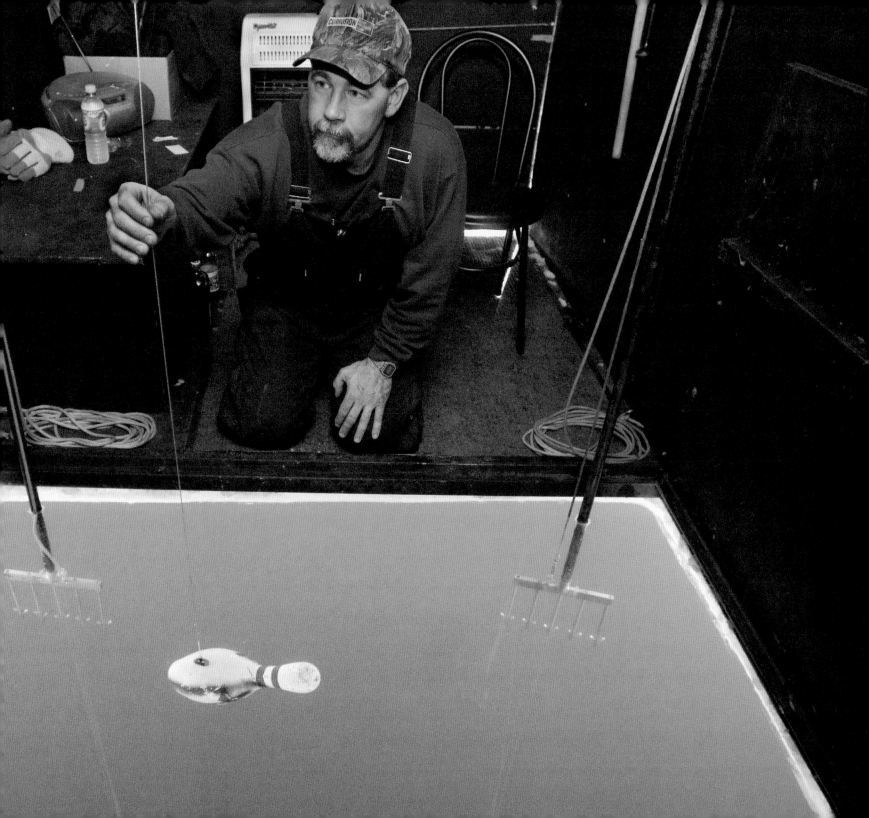

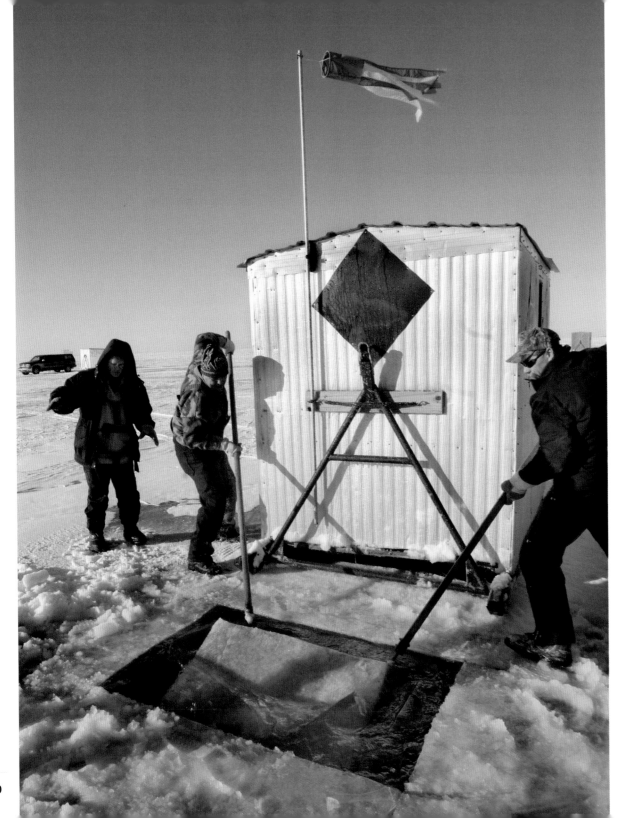

Submerging and sliding ice slab beneath lake ice to clear a spearing hole, Lake Winnebago.

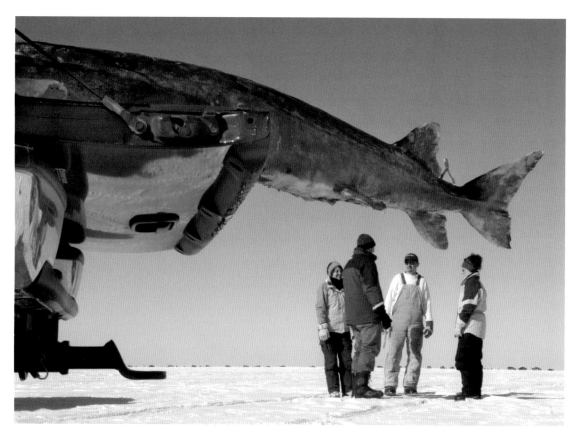

⬆ Lake sturgeon, 104 pounds, Lake Winnebago.

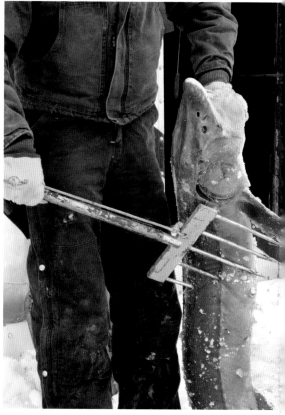

⬆ Lake Winnebago.

⬆ Buffalo Lake.

Anglers on the Ice Unite!

Anglers on the Ice Unite!

"Maybe KGB will lead us to where we are fishing today," said my friend, Oleg Voskresensky, as we motored down Moscow's dark streets at 4 AM in his Moskvich, a locally made agglomeration of grinding parts with an unslakable thirst for oil. "Your behavior is quite strange.

They can't understand how two adult men would travel across the ocean to do something unserious like fishing."

A policeman stepped out from a guard shack and flagged us to the shoulder. Oleg hopped out with passport and vehicle registration and returned to the Moskvich. Then we pulled ahead to our rendezvous with the officials of the Moscow Society of Angler-Sportsmen, who huddled in a ragtop jeep at the road-side. Moments later our two-car caravan set off on a quest to ice fish on Russia's Volga River.

There are three ingredients to ice fishing: ice, fish, and a fisherman. There's no shortage of these things at any number of places north of latitude 40 degrees. And so you find ice fishing from Iowa to Greenland to Mongolia. During my first trip to Russia, I noticed that up and down the Moscow River in the heart of the capital

men sat on stools and stared through holes in the ice. I realized, as any Minnesotan would, that they must be contemplating the existence of some leviathan beneath the ice—perhaps the zander, Europe's king-sized cousin of the walleye. Or the huge Russian pike. In a Russian tale, a foolish peasant named Yemelya catches a pike that promises to grant the fisherman's every wish if he sets the fish free. Yemelya does, and suddenly his chores do themselves, he flies aboard a woodstove to a meeting with the czar, he marries the czar's daughter, and he, the poor peasant, soon becomes czar.

So when I returned to Moscow with photographer Layne Kennedy, I packed my ice-fishing gear.

These were the days when there was a KGB and a Soviet Union, and a foreigner could not simply buy a license to go fishing. Oleg arranged a meeting with

Anatoly Petrovich Kaledin, chairman of the Moscow Society of Angler-Sportsmen, a quasi-governmental group that operated nearly two dozen fishing camps on the rivers and lakes around Moscow.

Burly and black-bearded, Kaledin spoke no English. But his expression alone suggested he was profoundly suspicious of two Americans who would track him down on the twisted back streets of Moscow, corner him behind his desk, and interrogate him about ice fishing. Nonetheless, with Oleg acting as interpreter, we arranged to fish at a Sportsmen's Society camp on the ice-bound Volga River, about seventy-five miles north of town. He agreed to arrange for fishing licenses and even mentioned that he might come with us.

"What tackle will we need?"

"Mormyshki," he said, showing us odd little jigs the size of BB shot. And sensitive tackle with light line, he added. "We have no crocodiles here."

"What about pike and zander?"

Not the right time of year, Kaledin said. So much for any dreams of marrying the czar's daughter.

Oleg, meanwhile, applied for permission to travel outside of Moscow. Several days after our meeting with Kaledin, Oleg called my hotel. "The authorities said they wanted us to go February 2, but the letter didn't arrive until February 3," Oleg reported. "So I arranged with Kaledin to fish tomorrow. They instructed him to talk to you about fishing and nothing else."

The next day, as we followed Kaledin over the dark landscape, I could only imagine the conversation in the car in front of us—of these Americans and their unlikely wish to fish the Volga in the dead of a Russian winter. It wasn't until years later that I learned that our destination of Dubna was the location not only of the Sportsmen's Society fishing camp, but also the Flerov Laboratory of Nuclear Reactions.

Twice more police hauled us over to inspect papers. Finally we arrived at a cluster of cabins in the woods, an Angler-Sportmen's Society base known as *Bolshaya Volga*—Big Volga. Kaledin disappeared into the main building. Moments later he reappeared and barked a few words in Russian. Our motorcade, which had grown suddenly to several vehicles, moved up the road.

The cars stopped at an intersection on the crest of a hill. A military truck roared up. Men jumped out and surrounded us. Then more vehicles pulled up—ragtop jeeps, civilian cars, school buses, and finally, frostbitten bikers in plastic ponchos riding big-fendered

motorcycles with sidecars. The motorcade lurched down an icy road, through a small Russian village of hewn-log homes with brightly painted shutters, and then onto the floodplain of the Volga. Two cars broke down and were shoved to the ditch as the procession rumbled on. As we reached the river, the cars, trucks, and buses stopped, and out poured waves of anglers carrying tackle boxes and ice augers. By sunrise, hundreds of Russians hunkered over ice holes.

Inside a log cabin we met our other fishing companions: Vladimir Nikolaevich Kondakov, a tournament fisherman from Moscow who would be our guide. And Kaledin's ten-year-old daughter, Sonya. "Today I'm babysitting," Kaledin explained. We dove into a breakfast of hot tea, bread, cold sliced sausage, wieners, and pickled mushrooms. Kaledin proposed a toast to our success. We each, except for Sonya, threw back a shot of vodka.

Kaledin and his daughter stayed behind, but the rest of us hopped on ancient snowmobiles and sleds. With a roar and clang of sheet metal, the antique one-ski snow machines flew over slush and patches of water and down the mile-wide river until, completely drenched, we reached our fishing spot.

Shaking the water off his jacket, Kondakov grabbed a small ice auger and drilled several holes through eighteen inches of soft ice. He explained we were fishing for *leshch*, a glorified shiner. Called "bream" in England, it may reach ten pounds on the Volga. He strung up a couple of the simplest but most delicate ice fishing outfits I have seen. The plastic reels held several dozen yards of two-pound-test monofilament. Kondakov threaded the line through a sliver of Mylar projecting from the end of the rod tip that served as an ultrasensitive "spring bobber." This was the tackle you'd use to catch guppies from your aquarium.

After Kondakov tied a *mormyshka* on each line, he unfolded a sheaf of damp newspaper, revealing a writhing mass of midge larvae. He threaded four on my *mormyshka* and lowered it down the hole, the spring bobber indicating when the bait barely touched the bottom, eighteen feet below.

Well, that's all I can report about *leshch* fishing. Neither Kondakov nor I caught one. A poll of other anglers in the area revealed similar bad luck. I finally found one old man with three small *leshch*. "Fishing's poor today," said the old man.

"Why?" Oleg asked. Oleg was not a fisherman.

"Maybe because it is Saturday," the old man said, smiling. "Seriously, too windy today. Wind creates pressure under the ice."

"Really?" Oleg said skeptically.

The old man laughed. "A good fisherman always finds a reason why the fishing isn't better."

With slim prospects of catching sizeable leshch, Kondakov resorted to a familiar North American guide's trick. "Let's move close to shore," he said. "I guarantee we can catch some perch."

We drilled several holes in five feet of water. Even Oleg decided to try for perch. We rebaited our mormyshki and dropped them down the holes. Soon Kondakov pulled up a six-inch perch. Oleg chortled as he, too, landed a perch the size of a fish stick. These Russian perch were beautiful, their pectoral fins bright orange and back and flanks a nearly iridescent dark green.

Within minutes, Kondakov and Oleg were surrounded by the frozen bodies of baby perch. Meanwhile, I stared stupidly into my ice hole and periodically checked the bait. Then Kondakov said something in Russian.

Oleg translated: "He says, 'You want to buy this hole?' He says he will sell it to you." At that moment,

appropriately, Kondakov caught another perch. "He says the price just went up." Enterprising for a Communist, I thought.

As the perch casualties mounted, Oleg began to patronize me. "Here," he said. "The fish are at this hole. Sit over here."

I wasn't in the mood. "No, that's okay."

"No, no. They are all over here," he said, landing another perch. "You come here." We traded holes.

Tiny and stupid though they were, the perch followed Oleg to my old ice hole, and he yanked in another as he chattered happily in Russian and English. By now it was nearly time to leave, and Sonya rode out on a snowmobile to join us for a few minutes on the ice. I gave Sonya my rod and jinxed hole—small sacrifice, all things considered. Within two minutes she pulled up a fish.

"Great American fisherman," Oleg said, "come here." By now I was sufficiently frustrated that I didn't hesitate. I had not flown 6,000 miles, ridden three hours in the back of a Moskvich, submitted to police inspections, and knocked back vodka for breakfast only to be skunked. I plopped down on Oleg's stool, dropped the mormyshka down the hole and began jigging

fervently. Suddenly, the rod tip twitched and, miracle of miracles, I winched up a perch four inches long.

"Now I know you're not a fisherman," Oleg said, eyeing the smallest fish of the day twisting on the line. "They are right. You must be a CIA agent."

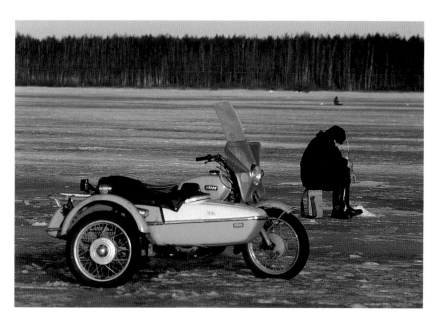

⬆ Soviet-era all-terrain vehicle, Volga River.

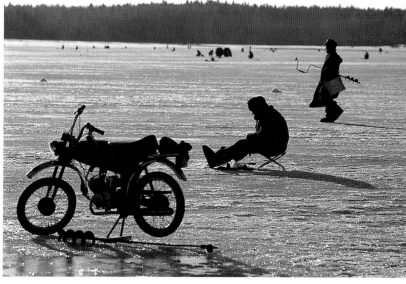

⬆ Cycle of the angling season, Volga River.

⤒ Landing a mighty Volga River perch.

➡ Makeshift shelter, Volga River.

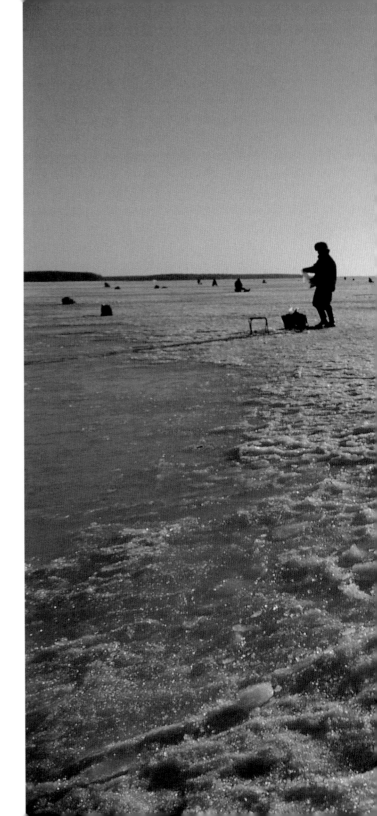

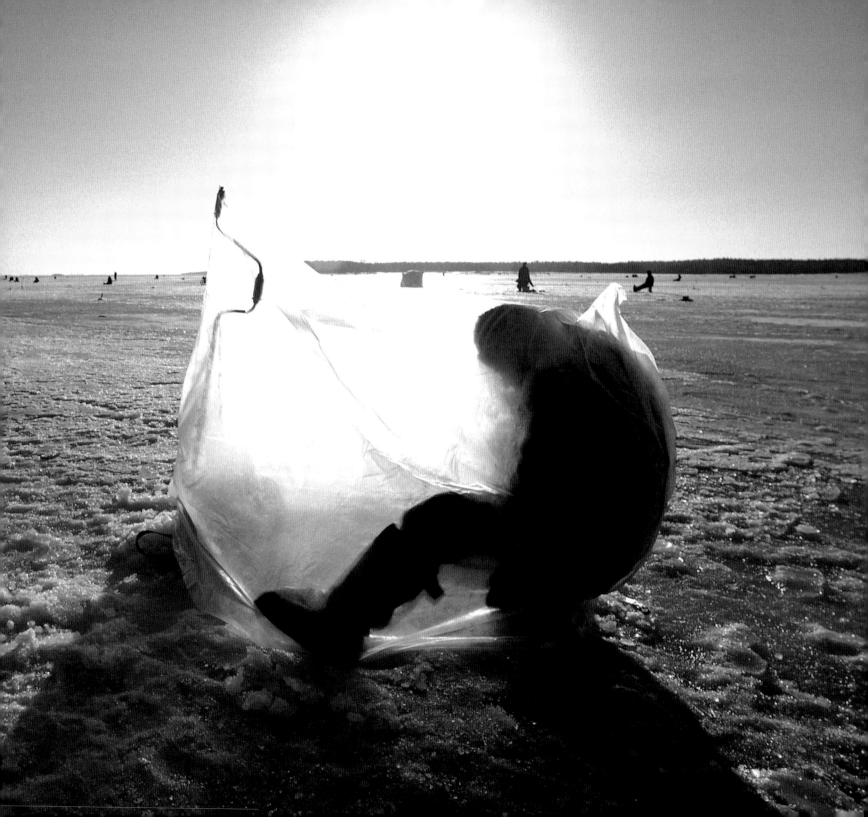

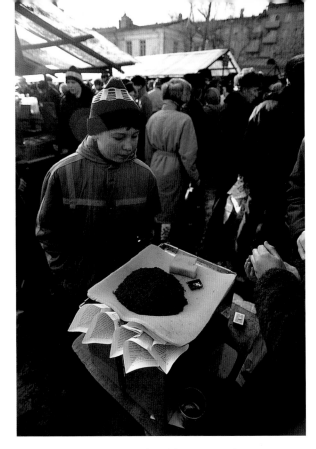

↑ Midge larvae for sale in a Moscow market.

↑ Russian cars parked along the Volga River.

↑ Anatoly Petrovich Kaledin, office of the Moscow Society of Angler-Sportsmen.

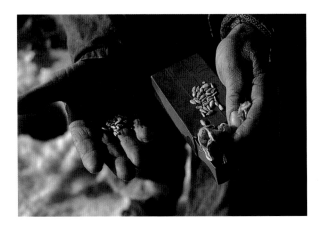

↑ A variety of baits, including sunflower seeds.

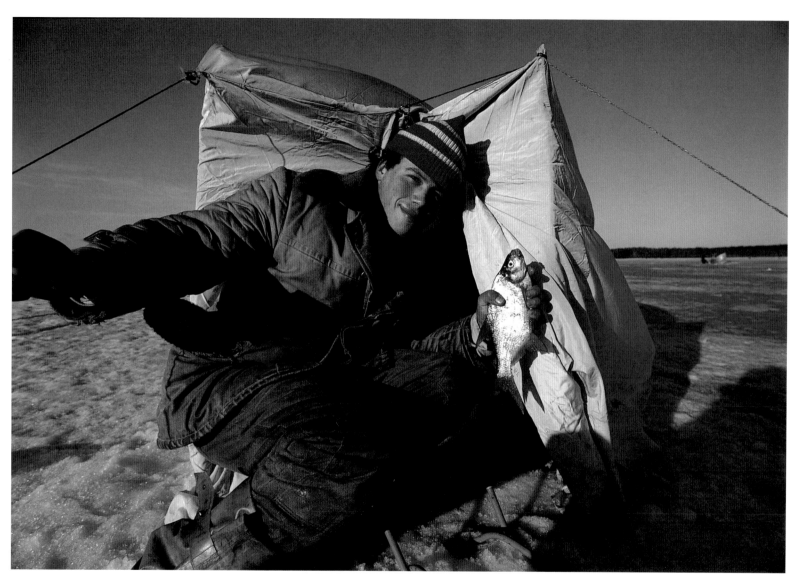

⬆ Young Russian with a *leshch*, known in English as bream.

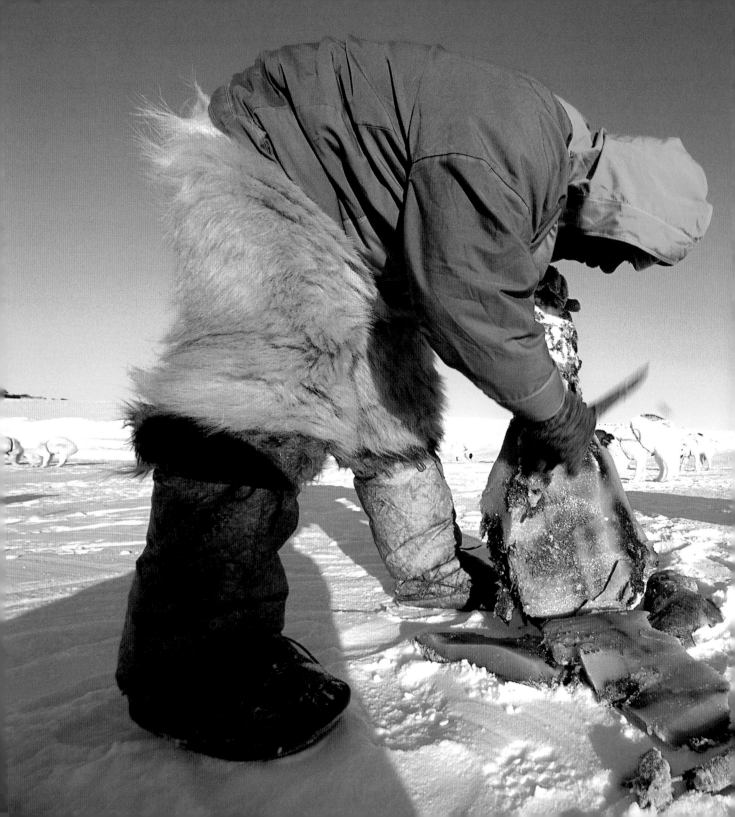

⬅ Cle

Theater of the Absurd

Theater of the Absurd

Ice fishing is the only sport I can think of—without actually thinking too hard about it—that routinely, knowingly, and even joyfully engages in self-parody. And I'm not talking about routine contests, even a competition as large as the Brainerd Jaycees Ice Fishing Extravaganza

on Gull Lake in Minnesota, with nearly 15,000 participants. All fishermen have contests. What they don't have is out-and-out deprecation of the sport they profess to love. What they don't have is irony.

One example: The "world famous" Fish House Parade, held each year the day after Thanksgiving in Aitkin, Minnesota. In a kick-off to the actual ice fishing season, up to 10,000 spectators (I rely here on estimates given out by parade promoters) line up to watch up to thirty fish-house floats roll through downtown. Awards are given for the most creative, most outrageous, and noisiest. There are also awards for "fish-house tales."

"The parade was spawned [a fish metaphor, I presume] from a keen sense of humor sharpened by dry Scandinavian wit and hardened by long Minnesota winters," say the organizers on their website. I'll just have

to take their word, since I'm not entirely sure what they mean. Perhaps that northern winters are boring, and tend to make people sarcastic and maybe a bit testy. Certainly it makes them ironic.

Similar in spirit, if not in form, is the play *Guys on Ice*, produced by American Folklore Theater of Door County, Wisconsin, about fishing buddies Marvin and Lloyd. Lloyd's wife bailed because he won't give up his tickets to the Green Bay Packers, who play the Chicago Bears on Lloyd's wedding anniversary. Marvin is sick of his job and can't work up the courage to ask out the checkout girl at the Pick 'n' Save. Their commiserations in the ice house provide the opportunity for snappy musical outpourings like "Ode to a Snowmobile Suit," "Fish is the Miracle Food," and "The One That Got Away." I haven't seen it, but I like the notion of "a

kind of 'Waiting for Godot' with regional accents." Minnesota writer Kevin Kling has tried to mine the same irony in *The Ice Fishing Play*, a "vibrant exploration of the struggle to connect in a world of blizzards, frozen minnows, memories and miracles." What, other than irony, could inform "a glimpse of the secret inner world of that mystical icon, the ice fisherman"?

The granddaddy of self-mockery on ice must be Tip-Up Town USA, held each January since 1951 on Michigan's Houghton Lake. Despite its long tradition, however, you can't help but feel it's straying from its theme. Recent carnivals feature chainsaw carving, vintage snowmobile racing, softball on ice, a beer tent with live music, and helicopter rides. Is there any opportunity just to ice fish? Even so, the renew-your-vows "wedding chapel" is probably something a lot of ice fishermen would benefit from.

For my money, the best of the lot is the Annual International Eelpout Festival on Leech Lake near Walker, Minnesota. I say that because despite the distractions, the event still has two things central to any good ice fishing festival—lots of fishing and lots of irony.

Really, what makes the festival so promising from the get-go is the subject—not simply a fish, or a game fish, or a prized fish, or any fish that under other circumstances someone might actually try to catch. No, this festival celebrates the eelpout, or burbot, a freshwater cousin of cod whose most notable trait is its appearance. Potbellied and barbeled, the eelpout looks like Jesse Ventura with fins. Its second-most notable trait: it's covered with slime, a quality that perhaps gave rise to one of its many other names, "lawyer." Which brings up its third-most notable trait, its spawning habits, as described by a fisheries biologist in 1936: "A dark shadow was noted at the edge of the ice, something which appeared to be a large ball. Eventually this moved out into view and it was seen to be indeed a ball—a tangled, nearly globular mass of moving, writhing *lawyers*."

The festival—that is, the *international* festival—is timed for mid-February, when the burbot bacchanalia is just beginning. The fish are staging and heading for shallower water. When the event started in 1980, the festival was doing well to attract 500 people. Now 10,000 show up.

There are distractions, to be sure: a snowmobile race, a car race (it would mean something if the cars towed ice houses), a polar plunge, and a rugby

match. Still, the festival remains true to its original intent—catching eelpout. In fact, the tournament awards prizes for the ten largest eelpout. In 2007, the prize for BIGGEST went to a young woman for a fish that weighed 14.62 pounds. (Note that the seriousness of this endeavor is carried to two decimal places.) But it doesn't stop there. Awards are given for Puniest Pout (0.36 pounds), Individual Tonnage (114.52 pounds), and Team Tonnage (431.98 pounds by Floyd's Barber Shop). Total tonnage classes are enhanced by the fact that the only limit on eelpout, in the words of one competitor, is "all you can stand." Finally, awards are given on style points, the élan, if you will, with which individuals and teams pursue their sport: Most Lavish Burbot Bivouac, and the Greatest Distance Traveled (from Anchorage in 2007).

There may not be limits. But there are rules. The most important is that eligible fish must not be frozen through and through—to prevent anglers from stockpiling eelpout throughout the winter. And if there is any doubt, according to the organizers, "a lie-detector test will . . . be used and if the eelpout fails, one will be administered to the angler."

The festival acknowledges that someone who takes ice fishing seriously is someone who can't quite be trusted. Perhaps his morals are questionable. Perhaps, by the nature of what she does, she can't be entirely sane. At the very least, he or she is a kidder and can't be assumed to be on the square. For all these shortcomings, the ice fisherman/woman isn't quite fit for polite society. Not that this is anything to be ashamed of. It may even be cause for celebration.

It's noteworthy that not least among the Eelpout Festival awards is the prize given for Hairiest Back. The winner of said award shall remain nameless, though notably it is a man. And he won for the second time running.

SO, IS EELPOUT FISHING the highest form of ice fishing? Well, no, but it does display the sport in high relief. The very fact of ice fishing, even to its practitioners and fans, is an acknowledgment that a person's desire to fish is a little out of control, a bit out there on the ragged edge of what is reasonable and normal. Self-effacing humor, even outright self-mockery, is a sort of cocoon, a source of ironic reassurance in the cold, dark days on the ice.

When, finally, the sun climbs, the weather warms, and—knowing that ice fishermen can't be trusted to regulate themselves—the law requires us to chop the ice houses free from the surface of the lakes, winter anglers tow their seasonal homes ashore to resume life once again among the well-adjusted.

And shortly thereafter, the ice itself will thin, break, pile up on the shore, and melt. And the world below will once again feel the full effect of sunlight and oxygen and join the world above.

↑ A pouter in disguise—sort of.

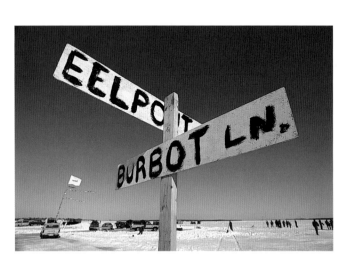

↑ Leech Lake, Minnesota, where all roads lead to pout.

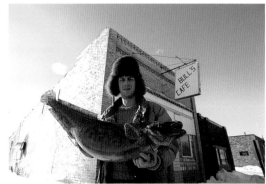

↑ Trophy eelpout, Walker, Minnesota.

→ Ice Fishing Extravaganza on Gull Lake.

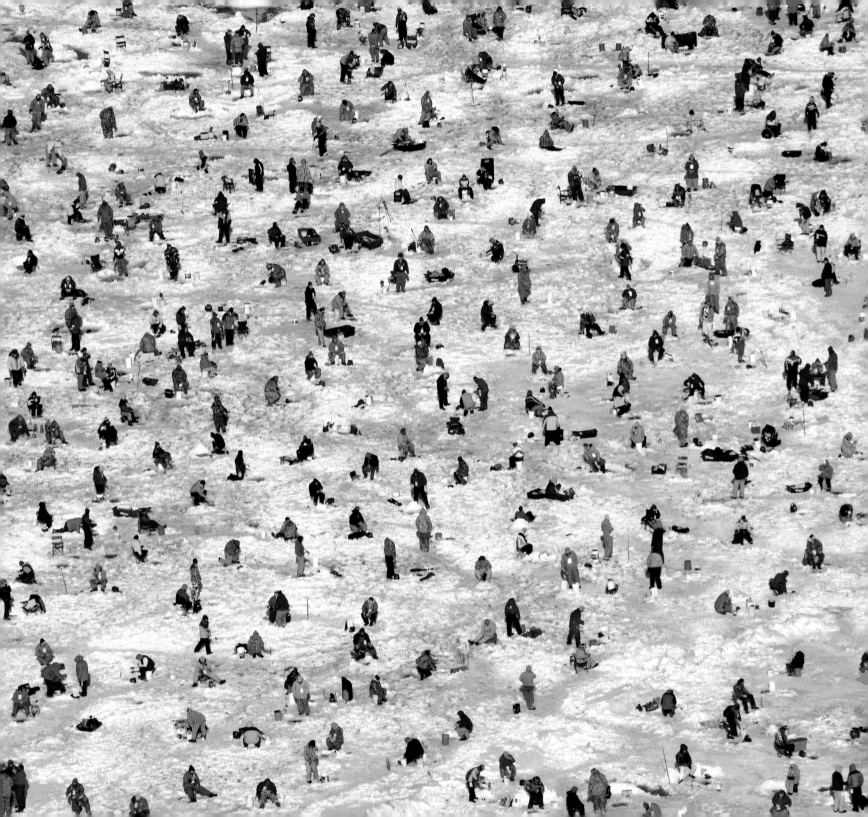

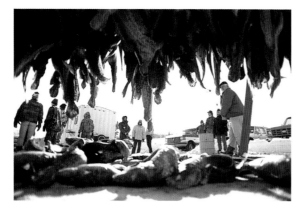

⬅ Eelpout, weighed and ready
to clean, Walker.

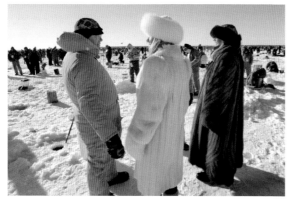

⬅ Ice Fishing Extravaganza, Gull Lake.

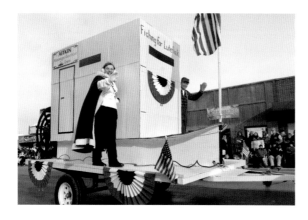

⬅ Fish House Parade, Aitkin, Minnesota.

→ Shining light on the secret world
of pouters, Walker.

⊡ Sebago Derby, Sebago Lake.

→ Sebago Derby.

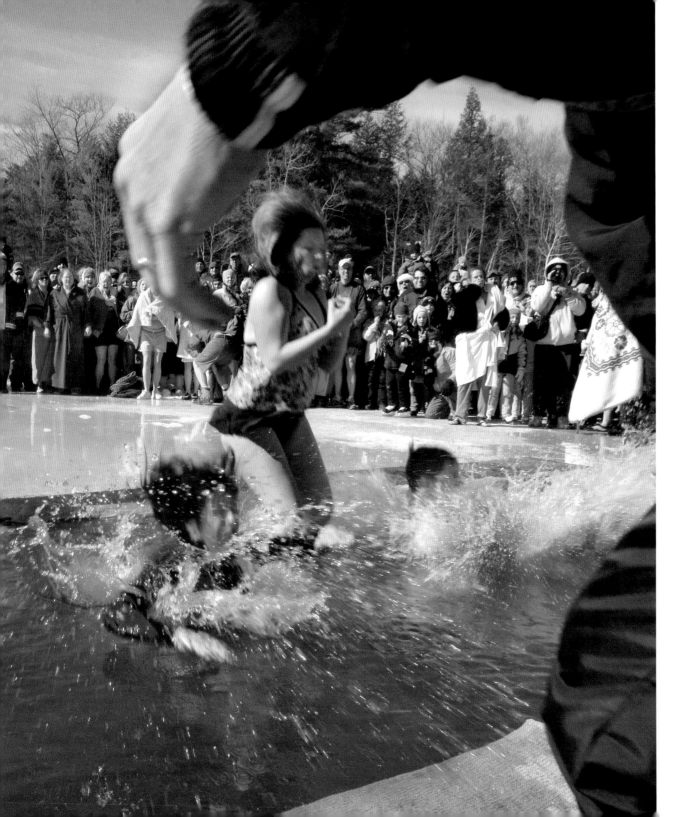

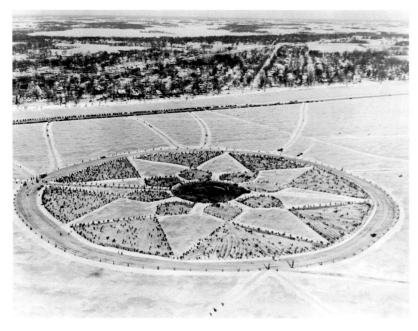

St. Paul Winter Carnival ice fishing contest in 1950, White Bear Lake, Minnesota. (MINNESOTA HISTORICAL SOCIETY)

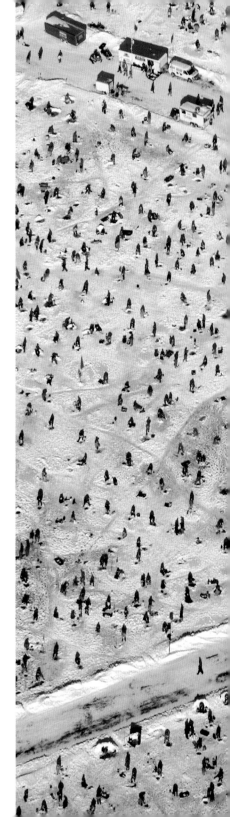

Lining up for weigh-in, Brainerd Jaycees Ice Fishing Extravaganza, Gull Lake, Minnesota.

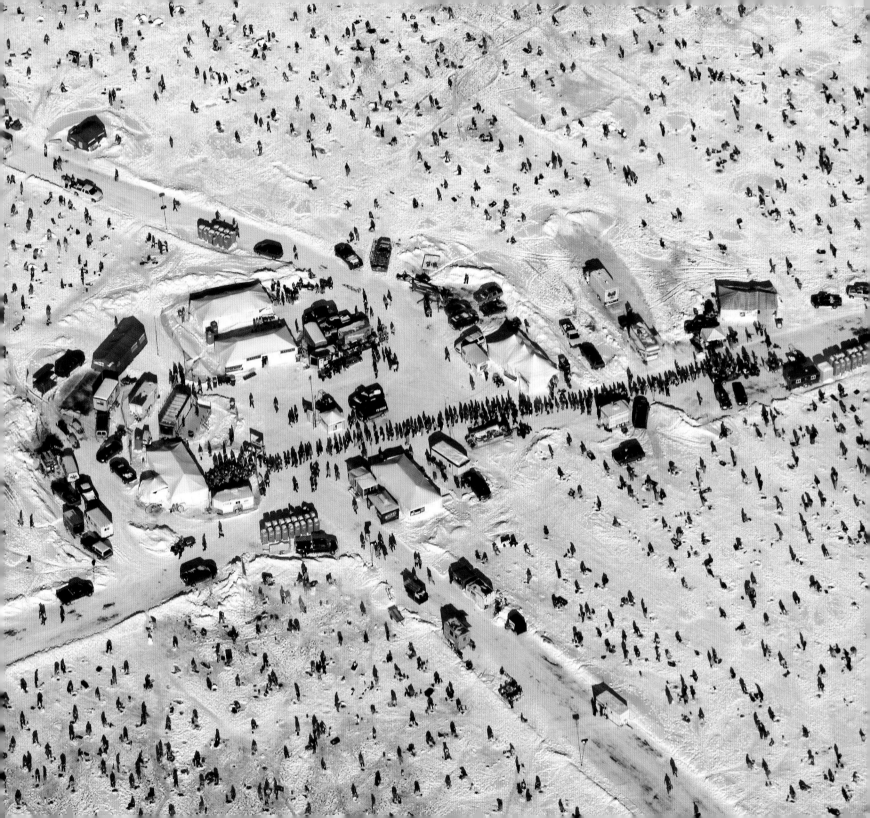

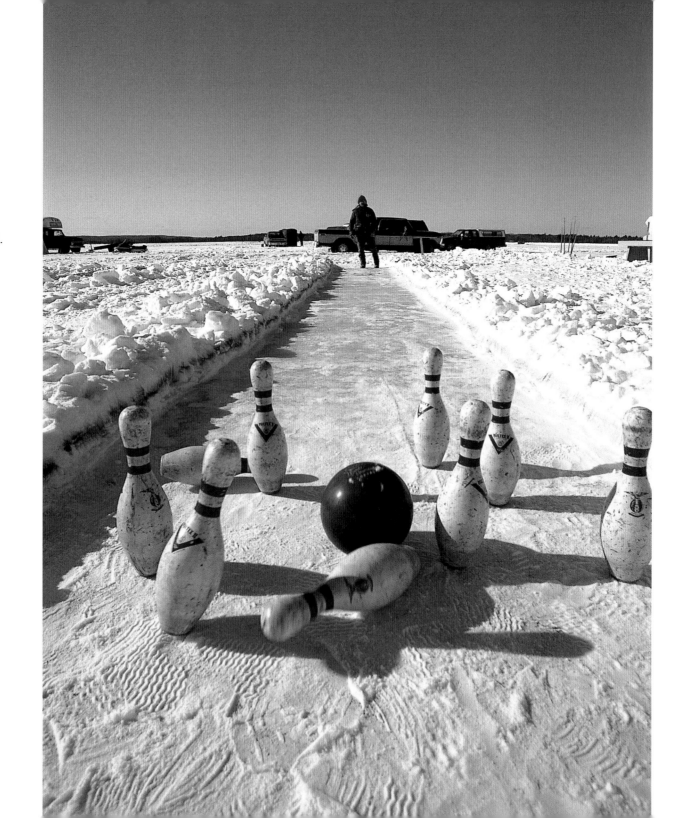

⇥ Eelpout Festival.

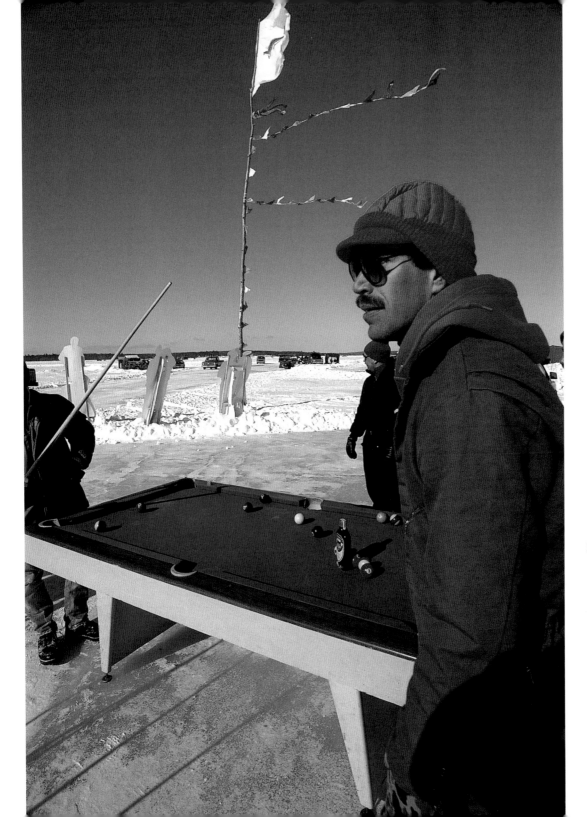

⊡ Hijinks at the Annual International Eelpout Festival on Leech Lake, Walker, Minnesota.

Hard-Water World
was designed and set in Joanna and Beta Sans
by Brian Donahue / bedesign, inc., Minneapolis.
Printed by C&C Offset Printing Co.